# Surrealism

Layout design by Jacques Douin

This translation first published
as a paperback original in Great Britain
in 1979 by Eyre Methuen Ltd,
11 New Fetter Lane, London EC4P 4EE,

ISBN 0 413 39880 3

Translation by Désirée Moorhead

Originally published in France
© Fernand Hazan, Paris 1978
This translation © Fernand Hazan,
Paris 1979
Reproduction rights reserved
S.P.A.D.E.M. and A.D.A.G.P., Paris
Printed in France by Jean Mussot, Paris

JOSÉ PIERRE

# Surrealism

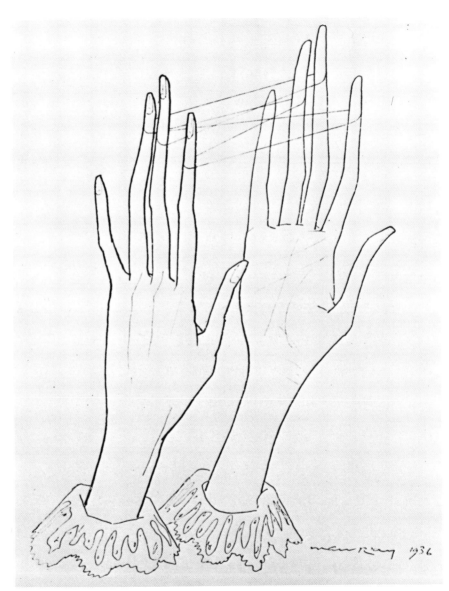

Man Ray
Solitaire
Drawing. 1936

The unity of the surrealist concept, which is a form of criterion, cannot be found in already travelled paths which might differ in all respects. It is to be found in the fundamental common aim: to arrive at the promised land which our time contrives to hide from us and to be able to explore it in detail until it reveals the secret of how 'to transform this life'.

<div align="right">

André Breton
*Trait d'union* (1952)

</div>

## Surrealism and its influence on painting

Surrealism sprang from a very singular event. In 1919 André Breton and Philippe Soupault together wrote the first surrealist book, *Magnetic Fields*. They used automatic writing or that which spiritists employed when they communicated with the spirits of the dead, but the two young poets used it towards a lyric end. Whereas a medium in trance is convinced that he is writing at the 'dictation' of some spirit or other, Breton and Soupault, thanks to their knowledge of psychoanalysis of which the former already had considerable experience, knew that the voice which suggested moving or funny passages in *Magnetic Fields* did not come from outside but was in reality the voice of their unconscious from within. Texts written from the medium state were not the only results of spiritism; drawings, engravings and paintings were equally the products of 'dictation' and often of a finer quality than the writings, as the former were not subject to the noxious influence of the ideas professed by Allan Kardec or Madame Blavatsky. These graphic and pictorial works shared two directions, one being characterised by a generally naif imagery, which however was rendered with feeling and was close enough in content to the symbolic imagery of the pre-Raphaelites and the

Rosicrucian Salons, while the other, which was far more original, was carried out in a sort of formal network at once extremely detailed and regular and at the same time agitated but curiously static. It almost always conveyed the feeling of an unshakeable inner assurance which, in our time, can be seen in the work of Madge Gill or of Scottie Wilson.

Given that these two categories of work each came from *automatism*, as neither were the result of reflection nor of aesthetic concertation but had obviously emerged under the influence of 'dictation', the British metaphysician Frederick William Henry Myers (1843-1901) indicated their differences of aspect by referring to the first as a 'sensorial' *automatism*, in which 'the products of vision and inner audition are exteriorised in such a way as to assume the character of quasi-perceptions', and to the second as 'motor' *automatism* which shows itself in 'inner motor impulsions independent of conscious will'. In other words the medium-influenced artists of the first

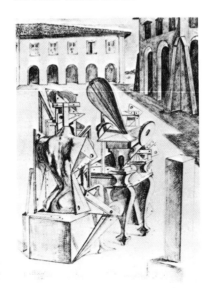

Chirico
Les Mathématiciens
Drawing. 1917

category had 'visions' or visual hallucinations of such intensity and clarity that they only had to recopy them on the canvas or sheet of paper. Those in the second category who were in no way 'visionaries' allowed themselves to be subjected to impulses imposed on them by what they referred to as 'their guide' and which we know to be none other than their unconscious. This distinction established

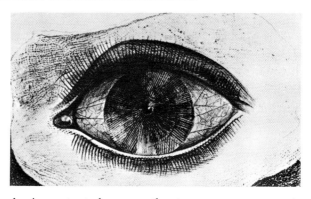

Ernst
La Roue de la lumière
Frottage. 1925

by Myers is extremely important because the two categories are found at the heart of surrealist painting but it is surprising to realise the favour thus accorded spiritism even if spiritist postulates were rejected. In reality spiritism stemmed from a much less suspect way of thought which from the mid-18th century onwards was interested in all forms of behaviour which escaped the rulings of logic and of reason and which on the scientific plane led to Charcot's research on hypnotism as well as that of the school of Nancy and eventually to the discoveries of Freud.

Early on, poets and painters felt concerned by these problems but they were not helped by an unbroken tradition, relayed rather than inaugurated by the description of the 'poetic fury' as proposed by Plato in *Ion*, which tried to convince them that a total submission to the violence of inspiration constituted the best way to

produce immortal works. This doubling of the creative personality – Stevenson's famous *Dr Jekyll and Mr Hyde* would later offer a 'diabolic' version while spiritism developed its own 'angelic' version – was inherent in English Romanticism as is apparent with Fuseli, William Blake, the 'black novels' and 'gothic novels' of Walpole, Ann Radcliffe, Lewis and Maturin and also in German

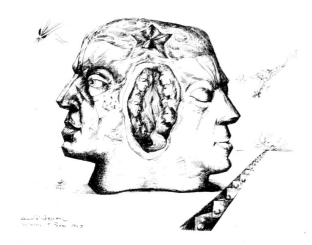

Masson
Portrait of André Breton
Drawing. 1941

Romanticism with the automats of Arnim and the sleepwalkers of Kleist, the paintings of Friedrich and the thoughts of Carus. Novalis wrote: 'The poet commands, combines, chooses, invents and he himself does not know why he acts in one way or in another'. From the other extremity of the 19th century Rimbaud would reply: 'The I is another. If the brass turns into a bugle it is not its fault. This much is clear, I am taking part in the maturity of my thoughts: I watch them, I listen to them. I draw my bow and a symphony murmurs in the depths or leaps onto the stage'. As for Isidore Ducasse-Lautréamont, Mr Hyde responds, as is known, to the name of Maldoror, which Breton one day applied to Tanguy spelling the name Malle d'aurores, also without a doubt Jarry is the Dr

Jekyll of Père Ubu. In the case of Roussel it is only possible to approach him having passed through numerous corridors decorated with lackeys in full livery and tirelessly repeating one after the other the famous dialogue, 'Dr Livingstone, I presume?' 'Dr Stanley, I suppose?'

The above goes to show that contrary to roasted larks and other celestial mannas, *automatism* did not fall from the sky but instead stemmed from a series of more or less adventurous investigations and hypotheses and, as a result, was even more worthy of attention in the eyes of the Surrealists, as they never really enjoyed what was already common knowledge and their intention was in reality to reveal the fabulous resources of the individual unconscious. In passing it should be remembered that the psychoanalysis of the Surrealists was influenced by Freud, and only by him, and not, as certain people quite wrongly affirm, by Jung and his so-called 'collective unconscious' which was so quickly adopted by complaisant Christianity (read Nazi). Returning to Surrealist painting, what is particularly interesting here is that it is evident that it did not fall from the sky and that apart from the long voyage towards acceptance of the unconscious as the privileged creator – or, to adopt the technical Freudian vocabulary, of 'id' – it also knew how to profit from the activities and the theories of its immediate precursors. In the first place Surrealism never denied its debt to Symbolist painting even though it only claimed direct allegiance to Gauguin, Gustave Moreau and Böcklin (however Duchamp, Max Ernst, Masson and Tanguy also appreciated the work of Odilon Redon). For these three painters what was important was also 'to arrive in the promised land' and 'to explore it in detail until it gave up the secret of how 'to transform this life', even if such a project seemed less deliberate on the part of Moreau and Böcklin than of Gauguin. The Surrealists were not impressed by the retinal euphoria of Impression-

ism nor by what they considered as the purely structural enterprise of Cézanne but they were fascinated by the sibylline approach of Seurat, as is witnessed in the following unpredictable sally of Breton: 'Seurat is a surrealist in his drawing'.

The decisive influence actually came from nearer sources and Henri Rousseau in *The Dream*, his last painting, can be considered as the first surrealist painter of the 20th century, while Picasso with his version of Cubism penetrated the surface of appearances and henceforward authorised any audacity. Duchamp, freed by the Cubist principles in regard to an 'exterior model', devoted himself to radically new speculation centred on the erotic. The quite extraordinary psychological temperament of Giorgio di Chirico enabled him to attain such a state of receptivity that each of his paintings between 1910 and 1919 was like a radioscope of his successive states of being; Picabia's perpetual curiosity never allowed him to doze under yesterday's decaying laurels. Others of lesser importance such as Matisse, Derain, Braque, Modigliani,

Picabia
Frontispiece for
*Littérature*
1923

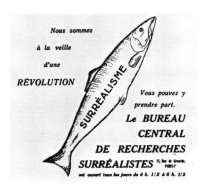

Announcement which appeared in the *Révolution surréaliste* 1924

Soutine and Chagall pale beside these models but are not devoid of all interest. Futurism, with perhaps the exception of Boccioni, did not live up to its theoretical pretensions and moreover its patriotic and military aspects were suspect. Dada which historically preceded Surrealism and which contained certain elements of the latter, had the merit of putting the contribution of Duchamp and Picabia in its proper light. Its subversive reach had greatly increased in the meantime and its sometimes superficial agitation which was always staunch in its contestation of recognised values prepared the way for Surrealism (also giving it several important artists, such as Arp, Max Ernst and Man Ray) and continued the revolt against the social and cultural moral order which they had committed themselves to undermine. Finally the work of Kandinsky must be taken into account and even though it was totally outside the domain of Surrealism it was, and still remains, closely linked with the most profound affinities of the spirit of the movement.

The number of stimulations which triggered the birth and spread of surrealist painting would not be complete without taking into account the example of those cultures, falsely called 'savage' or 'primitive', of Oceania and the Indian Americas (with the deliberate exclusion of Africa)

whose splendid utilitarian and cultural objects defy comparison, being as they are the result of a fervent collaboration of a people. This splendour and collaboration would not have been sufficient for the Surrealists if they had not found in Oceanic and Amerindian art, as well as that of the Alaskan Eskimoes, a frequently exceptional level of accomplishment inspired by this fusion of feeling and intelligence which found its greatest expression in the plastic domain. The art of the Indians of the North-West coast of America or the Malangan art of New Ireland represent the corroboration, even more precious as they are innocent of occidental influence, of the universality of 'the poetic view (surrealist) of things'. A wide gulf separates us from these 'primitives' but they can be associated with another category of 'primitive' at once distant but near to us who are schizophrenic artists. The total resources of these artists are mobilised in trying to reinvent a more harmonious world in which they would finally be permitted to live fully. Schizophrenia could really be the exacerbation of the fundamental creative attitude but in the 20th century it produced several extraordinary creative artists, particularly Adolf Wölfli, Aloïse and Frederic Schröder-Sonnenstern.

## The principal aspects
## of surrealist painting

The usual distinction made in surrealist painting between 'imagery' and the results of *automatism* does not hold up to examination. Indeed the intervention of 'trompe l'oeil' and of traditional perspective, which are held to be the criteria of surrealist 'imagery', can also be seen as being the result of an entirely unconscious approach, as is always the case with Tanguy and sometimes with Ernst, Dali, Masson and Toyen. Rather than subscribe to the analytical laziness of those who base such discrimination on badly interpreted appearances, it is

important to take into consideration the manner of specific ways of production of surrealist painting. The first would be mechanical automatism which includes all the procedures leading to the production of images in which hazard plays a major role and the artist a minor, as with the 'frottages' (rubbings) of Max Ernst, the 'decalcomanies' (transfers) without preconceived object of Dominguez, the 'fumages' (smoking) of Paalen, the 'grattages' (scrapings) of Esteban Frances, the 'coulages' (pourings) of Onslow-Ford and the 'écremages' (spreadings) of Conroy Maddox. These various procedures had in common that the effects obtained owed nothing to the use of a brush and all or nearly all had recourse to unusual aids – floorboards of strongly marked woodgrain, strings, candle flames, razor blades etc, all used in repetitive gestures totally lacking in inventiveness. In this way they can be attempted by the first comer and do not require any previous artistic formation, thus realising one of the primary objectives of Surrealism which was to accede to the marvellous through the ordinary objects of everyday life. All this seemed quite natural and constituted a link with the famous 'wall of Leonardo': on the surface of this old wall of begrimed stones Leonardo would advise his pupils to 'read' scenes of mythology or stories of battle if they found themselves otherwise lacking in inspiration. 'Leonardo's wall' of course was just one particular instance of the universal recourse to the 'reading of clouds'. Under all skies and throughout every period of time this permitted man to interpret the accidental forms proposed by nature, from rock to cloud to the unpredictable configurations that molten lead can form when thrown onto water, coffee grounds etc, and to perceive therein their near or distant destiny not only in an analogical and sometimes anthropomorphic manner but also in prophetic terms. Thus Surrealism renewed its links with the concept of magic which had been revalued by German Romanticism, in which the universe was the mirror of man who only needed to question nature and

its wonders in order to discover his own truth.

*Mechanical automatism* was characterised by a certain passivity except in the case where the artist decided to interpret the results obtained, as Max Ernst did with his 'frottages'. *Motor automatism*, which was discussed above in connection with spiritism, distinguished itself by the dynamic implication of the actual body of the artist. This was carried to its extreme manifestation by the action painting or 'gestural' painting of Pollock and other heroes of American Abstract Expressionism. The 'happening' undoubtedly signalled the parting of this gesturality from painting, and Body Art its regression away from painting. What was meant to be understood as freedom of expression was really the desire to give in to an inner pressure as completely as possible, by diminishing the strictures of censure and of aesthetic second thoughts even if this was only related to the canvas by a game of nervous and muscular mutations with all the pathetic pantomime this could engender. *Motor automatism* imposed a code of behaviour on pictorial activity

Dali
Drawing
1946

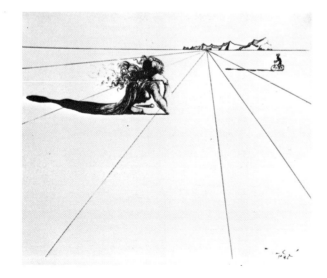

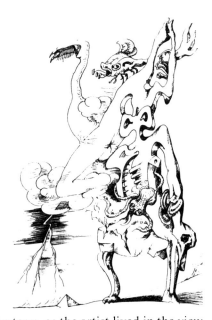

Masson
Apporté par l'orage
Drawing
1938

in the full sense of the term, as the artist lived in the view of the public, and at the same time it gave rise to a heroic attitude often close to sexual exhibitionism. This was as likely to light upon the visionary as upon the bitter disillusions of everyday life. And similarly the sparks of this erotic ecstasy glitter down the length of a way, royal though it may be, where the ascending slopes of mysticism and the ravines of auto-destruction are equally abundant. Matta, Gorky, Paalen, Tanguy and Hantaï are witnesses to this on the surrealist side and de Kooning, Pollock and Rothko on the Abstract Expressionist side. Artists like Motherwell, Hartung and Riopelle and to a certain extent Masson, Dali, Ernst and Miró were forewarned of the dizziness which could result from this encounter with Eros and they were able to steady the drive of *motor automatism* and come to grips with the resulting aesthetic problems. Breton realised this and he recorded the appearance of '*absolute automatism*' during

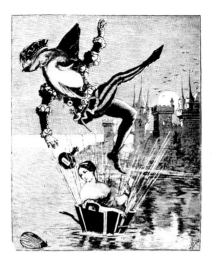

Ernst
Collage for the
*Révolution surréaliste*
1929

he years which preceded the Second World War with the chain Dominguez-Paalen-Matta-Frances-Onslow Ford. This was twelve to fifteen years after the first automatic or unconscious drawings of Masson and the tumultuous entry of Miró into surrealist painting.

With regard to drawing and colour, *motor automatism* answered to particular specifications and it would seem to be 'automatic drawing' which organises pictorial space in the work of Masson, Dali and Hayter. With Arp, Max Ernst and above all Miró it is more often 'automatic choice of colour' that carries out this function. Brauner, Toyen, Dax, Lagardo, Camacho and Silbermann are linked with the first method while Tanguy, Matta, Gorky, Donati, Hantaï and Gerber are closely connected with the second. This is beautifully apparent in their work in which the imagery is concocted from the principal ingredient which is colour. Here it is not only a question of technical difference but of a more profound difference, as in a way unconscious drawing, no matter how freely it is carried out, represents a form of lucid organisation and

is a link between the pieces of a puzzle furnished by the unconscious, which in turn it transcends with grace. The unconscious choice of colour flings itself into the primary colours acquiring a tender weight and a sensual depth, which while making it less attractive to the pure intelligence links it closely to the natural forces because at this level 'automatism' becomes a pact with nature. Certainly the distinction between these two attitudes is not as easy as the above development would have it: Masson was intrigued also by the relation of matter and colour, as is seen in his sand paintings, while for their part Arp, Tanguy, Miró, Matta, Gorky and Gerber also produced impressive works of a very personal graphic quality. However in each particular case one or the other inclination plays a determinant role and the only exception to this rule is Max Ernst. Not only was he a superb draughtsman but the graphic side of his work along with his 'collages' and 'frottages' is as important as the properly speaking pictorial side also linked to the 'grattages' and the 'décalcomanies'. Although Max Ernst can be considered as the all-round athlete of Surrealist painting, *motor automatism* does not play a large role in his work, which actually owes more to *mechanical automatism*. The most striking influence is really that of *sensorial automatism* which was previously discussed when referring to works of art produced from trance.

The quasi-hallucinatory character of *sensorial automatism* implies a more marked passivity than was the case in the use of mechanical procedures and as Breton wrote one day – 'it is only a question of tracing'. However, although such visual hallucinations are by no means shared by all in a similar manner, it is agreed that in surrealist painting, and outside of it, this category of *automatism* is the most difficult to understand, particularly when it is possible to have visual hallucinations and never think to translate them onto canvas. The least

questionable example to be offered as proof in support of the above is Giorgio di Chirico. He is of considerable importance in that he can be regarded as the prototype of the surrealist painter. Referring to him Breton would write: 'Later on, when talking amongst ourselves about the growing uncertainty of the mission entrusted to us, we would refer to this fixed point, like the fixed point constituted by Lautréamont, and he would determine the line we should follow'. Breton added: 'We never deviated from this line and it mattered little that Chirico himself lost sight of it because it was up to us to keep it in view.' (*Surrealism and Painting*, André Breton). For seven or eight years Chirico painted extraordinary works, as it were from 'dictation' springing from the depths of his most profound obsessions. These paintings possess a strange emptiness and awkwardness but at the same time they are full of an inner tension which stretches them to almost breaking point. They are wonderful and terrible works and in these scenes of Italian streets, of the Montparnasse railway-station, of arcades, towers, statues, fountains, vegetables and exotic fruits, the drama of human destiny is suspended. One day however the 'dictation' was brutally interrupted and Chirico, believing himself to be the equal of the great Venetian painters of the 16th century, began producing some of the most disgusting daubs in the history of painting. What happened will never be known. The history of Surrealism lists another example associated with Chirico and this is the sculptor, Giacometti. Within five or six years – a shorter lapse of time than accorded the painter of 'metaphysical landscapes' – he created a series of marvellous works in a sort of second state, then woke up one day to discover himself incapable of doing anything and this state lasted for about ten years. The case of Brauner also comes to mind. In 1930 and 1931 he painted several canvasses in which he depicted a damaged eye. One day, in 1938, during a quarrel between Oscar Dominguez and Esteban Frances he was hit by an object

thrown by Dominguez at Frances and subsequently lost the sight of his left eye. The presence of *sensorial automatism* is also obvious in the 'collages' of Max Ernst and in the works of Bellmer, Leonora Carrington, Silbermann and Toyen and today is the principal influence for the young Japanese artist, Yoshiko.

*Sensorial automatism*, as seen in Chirico's work, made use of objects but this was done in such a subjective fashion that we are secretly aware that these objects have the value of signs or symbols. Early on, the object would find special favour in the eyes of the Surrealists, be it a real and tactile object or an object more or less faithfully reproduced on the canvas. Indeed the object is the limit but not the frontier of subjectivity as this subjectivity tries to possess the object but fails and is forced to admit that an object is an object. Hence transitional objects, as described by Winnicott, which, in the form of a knotted hankerchief, a pillow or furry toy, serve as a mother-substitute for a child do not loose their status as objects. Breton, in 1924, in his *Dissertation on the Lack of Reality* underlined the effective realization of imaginary objects met with in dreams, while at the same time the Surrealists

Oppenheim
The Fur-lined Teacup
1936

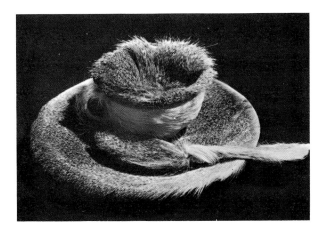

were becoming familiar with real but not generally identifiable objects such as those encountered when out on a stroll, in an attic or at the Flea Market. From then on a dialectical relation was established between 'found objects' and 'dreamed objects' and the former benefited from the initiative of Marcel Duchamp's ready-mades while the second opened the way to two types of different solutions – on the one hand the surrealist object and on the other, surrealist sculpture. On a parallel course the figurative object assumed an important place in the painting of Magritte and was an essential part of the enterprise. This was quite subversive in that it refused to recognise in the objects used the slightest symbolic significance, and in this way they were better able to elude the influence of subjectivity. In the case of Magritte this constituted a veritable terrorist campaign whose target was to reduce the chocolate-box type of painting to dust by casting doubt on the most elementary convictions as concerns objects or their figurative representation. What happens to an object if its name is taken away, its usual substance, its allure, its function, its dimension, its physical and moral properties? For twenty years Konrad Klapheck has furnished an entirely original complement to the uncertainty which hovers simultaneously on the visible world and on the language of figuration, because if he accepts and accords an importance to the minor objects of everyday life such as typewriters, roller skates and steam irons, he finds himself obliged to describe them in subjective terms. In Surrealist painting 'found objects' finished by acquiring a very marked subjectivity while 'dreamed objects' (Dali, Dominguez, Toyen and Tovar) tend to assure us of their perfect objectivity.

So-called *surrealist objects* can also be classified under two principal headings by the manner in which they lend themselves to the demands of humour. The result is 'humorous objects' and the classic example is *The Fur-lined Teacup* by Meret Oppenheim. Such objects can also

be used in the search for an 'objective hazard' or perhaps a 'wild passion' and in such cases can be referred to as 'objects of chance' like Valentine Hugo's *Surrealist Object of Symbolic Function*. As concerns surrealist sculpture the two tendencies fundamental to work carried out in trance are evident. The early part of Giacometti's work is influenced by *sensorial automatism* as was, later on, that of Maria Martins, Isabelle Waldberg and more recently the Californian sculptor, Jeremy Anderson. *Motor automatism* is principally illustrated by Arp and by the work of Henry Moore in the thirties and today by Augustin Cardenas. It is more important however to notice that in the current of the plastic arts which has been influenced by Surrealism, a harmonious translation is established from automatism to object and stern automatic subjectivity seems to have no further function than to substantiate the people, forms and colours torn from the inner night of the artist. Reciprocally even the most utilitarian object seems to aspire to cover itself with all the fires of subjectivity. This can be easily verified in British Surrealism as the works of Eileen Agar, Conroy Maddox and Roland Penrose are invaded by the object

while John Banting, Ithell Colquhoun and Paul Nash practise automatism but without there being any real divergence between the two. It is also noticeable in certain aspects of Pop Art, particularly with Oldenburg whose humorous objects are really of a total subjectivity which approaches them singularly to the pictorial pursuits of artists like Klapheck.

## Present and future of surrealist painting

Twelve years after the death of André Breton it is obvious that surrealist painting continues. Not however in the way wished by those who on the day after the publication of the first *Manifesto* tried to promote what they called post-surrealism. Not either under the daily aspect of a rapidly increasing degeneracy in which the older artists have lost sight of their previous exploits and the younger ones try in vain to follow in their footsteps. However this need not give rise to a ridiculous and ill-founded jubilation because, at least in the opinion of this author, nothing seems to authorise the pretence of a rebirth of Surrealist painting since 1966. Some remarkable artists have emerged during this period but can probably be regarded as swallows announcing springtime. Perhaps the problem should be posed in terms of global strategy as practised by the great international powers? In that case, and despite so many publications and exhibitions dealing more or less directly with the artistic implications of Surrealism, it is clear that the inherent hostility to Surrealism, manifest with the majority of collectors, curators of museums, art critics and art dealers, has not diminished in the least. The memory of André Breton still contrives to be insulted when it is a question of celebrating one or other leader of the Surrealist painting of yesterday although it is obvious that without Breton's impetus such painters would be unknown today. Efforts are also continually made to obscure as much as possible

Breton's relation to the moral principles of Surrealism, and the usual refrain is: Of course this great man brought a very precious contribution to Surrealism but on the other hand Surrealism brought nothing to him – his genius was sufficient in itself. A further example of such miserable initiative is to be seen in the catalogue of that extremely expensive and evasive exhibition, *Paris-New York*, held at the Pompidou Centre in Paris during the summer of 1977. The space accorded to that part of the exhibition reserved for the movement founded by Breton was given the heading of '*Surréalismes*'. This use of the plural was no doubt employed to further mask the singularity of a movement which is still very badly received. Despite the obvious merits of the superb exhibition in London at the beginning of 1978 entitled, *Dada and Surrealism Reviewed*, it must be noted that it systematically took no notice of all of twenty-five years of surrealist painting and of such artists as Hantaï, Svanberg, Dax, Lagarde, Laloy, Molinier, Camacho, Benoît, Gironella, Silbermann etc.

Such consistent ostracism is moreover a source of delight and the death of Surrealism will be recorded the day when it no longer gives rise to the slightest objection or fury on the part of selectors of exhibitions, newspapers and publishing houses. Today it is a fact that the art market has placed itself almost to a man under the flag of a dominant ideology which is in absolute contradiction with the exigencies of Surrealism. American Minimal Art, and its paler European imitations, only accord favour to painting which is only painting, that is to say that which forbids any modulation, vibration, emotion, form, any manifestation of the sensitive and even more of the unconscious and of myth. This not only places it in opposition to Surrealism but to art in its entirely, not only in financial terms but also psychologically and aesthetically ever since man has existed and taken an interest in works of art. This admirable conjugation of puritan

iconoclasm, of neo-positivist empiricism and of Wall Street is sometimes – like the olive in a dry martini – accompanied by a pinch of Maoist ideology. However *automatism* still exercises a very strong influence, despite the opposition of current artistic doctrines of art dealers and the like, and this influence is largely due to the fact that American painters and sculptors have seen through the various subterfuges proffered them and have realised that it is thanks to the automatic writing of the Surrealists that the generation of Abstract Expressionists was able to find their own psychic energy and a means of freeing themselves of their cultural dependence on Europe.

The crushing weight of the ideology of Minimal Art dominates the American avant-garde but it is clear that a version of the *automatic*, a surrealist version, is being carried on even if it does not overtly brandish the Surrealist flag. This is important because since their eruption in the front rows of the international avant-garde American artists have evinced a violence, a freshness and a conviction in their various undertakings which has not always found favour with their European colleagues. Maybe those European artists who do not bow before the official doctrine of the Minimalists and post-Minimalists should adopt a less rigid creative attitude and pay less attention to the eternal discussions on theory. As a result they might find themselves possessed of the same energy as the adventurous Americans and together they could do away with the burden of puritan iconoclasm and at the same time give back to Surrealism the colours of the future, those of 'the promised land.'

# Chronology of Artistic and Poetic Surrealism

### 1910
Death of Henri Rousseau.
Chirico: *The Enigma of the Oracle*.
Kandinsky: *First Abstract Watercolour*.
Picasso: *Portrait of Kahnweiler*.
Rousseau: *The Dream*.
*Technical Manifesto of Futurist painting*.
Roussel: *Impressions of Africa*.
Birth of Chaissac, Gracq, Jeanne Graverol, Hérold, Schehadé, Ubac, Unik and Julian Trevelyan.

### 1911
Chirico: *The Enigma of the Hour*.
Braque: *The Portuguese*.
Appearance of the review, *Les Soirées de Paris*.
Saint-John-Perse: *Eulogy*.
Birth of Matta, Okamoto and Stahly.

### 1912
Braque: first collages.
Cheval, the postman, finished his *Ideal Palace*.
Duchamp: *The Bride*.
Picasso: *Man with Clarinet*.
Kandinsky: *Black Ark* and *Concerning the Spiritual in Art and in Painting*.
Birth of Baziotes, John Cage, Granell, Conroy Maddox, Magloire-Saint-Aude, Onslow-Ford, Pollock, Svanberg and Dorothea Tanning.

### 1913
Duchamp: *The Chocolate Grinder*.
Matisse: *Portrait of Madame Matisse*.
Picabia: *Udnie, Young American Girl*.
Picasso: *Woman in Vest*.
Apollinaire: *Alcohols* and *The Cubist Painters*.
Birth of Arenas, Caillois, Césaire, Dax, Etienne-Martin, Luca, Meret Oppenheim, Remedios, Rothko, Trenet, Wols. Death of Trakl.

### 1914
Chirico: *Song of Love*.
Derain: *The Knight X*.
Lesage finished first painting from trance.
Picasso: *The Glass of Absinthe*.
Roussel: *Locus Solus*.
Birth of Frances, Heisler, Hénein and Paz.

### 1915
Chirico: *The Seer*.
Duchamp began his 'big glass'.
Picabia: *Very Rare Painting on the Earth*.
Savinio: *Songs of the Half-Dead*.
Birth of Malrieu, Motherwell and Schultze.

### 1916
Death of Boccioni, Franz Marc and Redon.
Arp: first 'automatic' drawings.
Apollinaire: *The Poet Assassinated*.
Reverdy: *The Oval Sky-light*.
Birth of David Gascoyne and Unica Zürn.

1917
Arp: *The Forest.*
Chirico: first 'metaphysical interiors'.
Picabia: *Lovers' Parade.*
The reviews, *Dada* and *391* founded.
Max Jacob: *The Cornet of Dice.*
Birth of Leonora Carrington, Hare, Isabelle Waldberg.

1918
Death of Apollinaire.
Apollinaire: *Calligrammes.*
Picabia: *Poems and Drawings of the Motherless Girl.*
Tzara: *Dada Manifesto 1918.*
Birth of Penalba.

1919
Death of Vaché.
Ernst: first collages.
The review *Litterature* founded.
Breton-Soupault: *Magnetic Fields.*
Vaché: *War Letters.*

1920
Death of Cravan, Modigliani, Nouveau and Panizza.
Ernst: *It is the Hat which makes the Man.*
Birth of Alan Davie, Laloy and Gisèle Prassinos.

1921
Ernst: *Oedipus Rex.*
Duchamp: *Why not sneeze?*
Man Ray: first rayograms.
Peret: *The Transatlantic Passenger.*
Birth of Jeremy Anderson, Radovan Ivsic and Ursula.

1922
Picabia: *Optophone.*
Soupault: *Westwego.*
Birth of Jean Benoît, Pol Bury, Hantaï, Stamos, Stankiewicz and Westermann.

1923
Duchamp 'unfinishes' his 'big glass'.
Ernst: *The Revolution of Night.*
Masson: *The Four Elements.*
Breton: *Clair de Terre.*
Péret: *At 125 boulevard Saint-Germain.*
Tzara: *Concerning our Birds.*
Birth of Caceres, Francis, Ginet, Judit Reigl, Riopelle and Tapiès.

1924
Death of the postman, Cheval and Kafka.
Ernst: *Two Children are Menaced by a Nightingale.*
Masson: first 'automatic' drawings.
Miró: *Ploughed Earth.—Catalan Landscape (The Hunter).*
The review *The Surrealist Revolution* was founded.
Breton: *Surrealist Manifesto. —Soluble Fish.*
Birth of Baj, Mimi Parent, Segal and Zimbacca.

1925
Death of René Ghil.
First surrealist exhibition in Paris.
'Cadavre exquis' first invented.
Arp: *Dancer.*
Ernst: first 'frottages'.

Miró: *The Harlequin's Carnival.*
Péret: *He was a Female Baker (Il était une boulangère).*
Birth of Dova, Duits, Rauschenberg and Tinguely.

1926
Surrealist Gallery opened in Paris.
Tanguy: *The Sleeper.*
Aragon: *The Peasant of Paris.*
Eluard: *The Capital of Sorrow.*
Birth of Benayoun, Cabanel, Filliou, Robert Hudson, Revel, Alina Szapocznikow and Villeglé.
Masson: sand paintings.

1927
Picabia: first transparencies.
Tanguy: *Mummy, Papa is hurt!*
Crevel: *Spirit Versus Reason.*
Desnos: *Liberty or Love!*
Birth of Alechinsky, Cárdenas, Kienholz, Legrand, Christian d'Orgeix, José Pierre and Trova.

1928
Death of Filiger.
Desnos-Man Ray: *Star of the Sea.*
Ernst: *The Chaste Joseph.*
Magritte: *Threatening Weather.*
Aragon: *Treatise of Style.*
Bataille: *History of the Eye.*
Breton: *Nadja.—Surrealism and Painting.*
Péret: *The Great Game.—And the breasts were dying . . .*
Birth of Agam, Arman, Bounoure, Fahlström, Wally Hedrick, Jouffroy, Yves Klein, Lagarde, Le Maréchal and Joyce Mansour.

1929
Death of Hélène Smith and Rigaut.
Bunuel-Dali: *An Andalusian Dog.*
Dali: *Illuminated Pleasures.*
Ernst: *The Woman of 100 Heads.*
Breton: Second Surrealist Manifesto.
Chirico: *Hebdomeros.*
Crevel: *Are you all mad?*
Birth of Bedouin, Gironella, Oldenburg and Schuster.

1930
Death of Wölfli.
Bunuel-Dali: The Golden Age.
Ernst: *Diary of a little girl who wants to enter Carmel.*
Giacometti: *The Hour of Traces.*
The review, *Surrealism as a help to revolution*, was founded.
Aragon: *Painting to the defence.*
Breton-Eluard: *The Immaculate Conception.*
Desnos: *Body and Goods.*
Birth of Duprey, Jasper Johns, Marisol, James Melchert, Niki de Saint-Phalle, Saura, Spoerri and Tsoclis.

1931
'*Surrealist objects with a symbolic functioning*'.
Arp: first 'torn papers'.
Calder: first mobiles.
Prévert: *Attempt to describe heads at a dinner in Paris-France.*
Tzara: *The Approximate Man.*
Birth of Robin Page and Wesselmann.

1932
Dali: *Birth of Liquid Desires.*
Jacques and Pierre Prévert: *The Affair is in the Bag.*
Breton: *The Communicating Vases.*
Crevel: *Diderot's Harpsichord.*
Eluard: *Immediate Life.*
Birth of Arrabal and Der Kevorkian.

1933
Death of Roussel.
Giacometti: *The Palace at 4 p.m.*
Kandinsky was guest of honour of the Surrealists at the Salon des Surindependants.
The review, *Minotaure*, was founded.
Breton: *Unconscious Message.*
Mesens: *The Deaf and Dumb Alphabet.*
Birth of Bruce Conner, Pasotti and Rosenquist.

1934
Death of Séraphine.
Brauner: *The Strange Case of Mr. K.*
Dali: *The Ghost of Vermeer which can be used as a Table.*
Ernst: *A Week of Goodness.*
Moore: *Two Forms.*
Man Ray: *At the Hour of the Observatory—the Lovers.*
Styrsky: *The Bathing Party.*
Toyen: *The Red Spectre.*
Breton: *Light of the Bride.*
Char: *The Masterless Hammer.*
Duchamp: *The Green Box.*
Péret: *Behind the Faggots.*
Birth of Camacho, Ballaine, von Holten and Saul.

1935
Death of Crevel and Malevitch.
International exhibitions of Surrealism at Copenhagen and Tenerife.
Bellmer: *The Doll.*
Giacometti: *The Invisible Object.*
Magritte: *The Human Condition II.*
Eluard: *The Public Rose.*
Gascoyne: *A short survey of Surrealism.*
Picasso: surrealist poems.
Gisèle Prassinos: *The Arthritic Grasshopper.*
Roussel: *How I wrote some of my books.*
Hugh Sykes Davies: *Petron.*
Birth of Adami, Ivor Abrahams, Ben, Jim Dine, Marianne van Hirtum, Klapheck, Kudo and Silbermann.

1936
Death of Lorca.
Exhibition of surrealist objects in Paris. International Surrealist exhibition in London.
Dominguez: The '*decalcomanie du desir*'.
Ernst: *Echo the Nymph.*
Hayter: *Ophelia.*
Nash: *Encounter in the Afternoon.*
Oelze: *Waiting.*
Meret Oppenheim: *The Fur-lined Teacup.*
Chavée: *The Human Ashtray.*
Eluard: *Fertile Eyes.*
Péret: *That is not the sort of bread I eat.*
Read: *Surrealism.*
Birth of Jean-Jacques Lebel, Martial Raysse and Samaras.

1937
Exhibition of surrealist objects in London.
Arp: *Giant Pip*.
Paalen: *Totemic Landscape of my childhood*.
Penrose: *Captain Cook's last Voyage*.
Banting: *Woman passing between two Musicians*.
Toyen: *Sleeping Woman*.
Moore: *Reclining Figure*.
Blanchard: *The Mysterious Barricades*.
Breton: *L'Amour fou*.
Chår: *Cupboard for the Schoolchildrens' Path*.
Queneau: *Chêne et Chien (Oak and Dog*.
Birth of Télémaque, Vermeille and Wiley.

1938
Death of Emile Cohl and Méliés.
International exhibition of Surrealism in Paris.
Colquhoun: *Scylla*.
Frances: 'grattage'.
Freddie: *My Two Sisters*.
Paalen: 'fumage'.
Penrose: *Magnetic Moths*.
Tanguy: *The Ears of a Deaf Man*.
The review, *London Bulletin*, was founded.
Artaud: *The Theatre and its Double*.
Breton-Eluard: *Abbreviated Dictionary of Surrealism*.
Breton-Trotsky: *Towards a Revolutionary and Independent Art*.
Calas: *Houses of Fire (Foyers d'Incendie)*.

Gracq: *At Argol's Castle*.
Leiris: *The Age of Man*.
Birth of Jean-Francois Bory, Gilles Ghez, Jim Nutt, David Oxtoby and Roland Piché.

1939
Death of Freud.
Brauner: beginning of 'Chimeras'.
Herold: *Heads*.
Masson: *Gradiva*.
Matta: *Psychological Morphology*.
Melville: *The Concavity of Afternoons*.
Onslow-Ford: 'coulages'.
Picasso: *Fishing in Antibes*.
Tunnard: *Fulcrum*.
Leonora Carrington: *The Oval Lady*.
Césaire: *Account of a return to the native land*.
Duchamp: *Rose Sélavy*.
Eluard: *Donner à Voir*.
Mayoux: *Ma tête à couper*.

1940
Death of Maurice Heine, Klee, Saint-Pol-Roux and Trotsky.
Exhibition of *Surrealism Today* in London.
The 'game of Marseilles'.
Agar: *The Angel of Anarchy*.
Kandinsky: *Blue Sky*.
Maddox: *Passage of the Opera*.
Moore: *Helmet*.
Breton: *Anthology of Black Humour*.
Mabille: *Mirror of the Marvellous*.
Birth of Clive Barker, William Geis, Bert Kitchen and José Pereira.

1941
Ernst: *Napoleon in the Desert*.
Miro finished his 'Constellations'.
Onslow-Ford: *The Painter's Temptations*.
Breton: *Genesis and Artistic Perspective of Surrealism*.
Magloire-Saint-Aude: *Dialogues de mes lampes, Tabou*.
Picasso: *Desire caught by the Tail*.
Birth of Tom Gutt and Bruce Nauman.

1942
Death of Gonzalez and Styrsky.
International exhibition of Surrealism in New York.
Matta: The Earth is a Man.
Moore: *Crowd Looking at a Tied-up Object*.
Tanguy: *Infinite Divisibility*.
The Review, *VVV*, was founded.
Breton: *Introduction to the Treatise on the Third Surrealist Manifesto or Not*.
Queneau: *Pierrot my Friend*.
Birth of Sue Bitney and Tovar.

1943
Death of Soutine.
Donati: *The Bolero*.
Hirshfield: *Two Women before a Mirror*.
Kandinsky: *Circle and Square*.
Lam: *The Jungle*.
Mondrian: *Broadway Boogie-Woogie*.
Motherwell: *Pancho Villa lives dead or alive*.
Leiris: *Haut Mal*.
Moro: *The Castle of Grisou*.

Nougé: *René Magritte or Forbidden Images.*
Thirion: *Le Grand Ordinaire.*
Trenet: *The Infernal Heritage.*
Birth of Ascal and Annette Messager.

1944
Death of Max Jacob, Kandinsky, Mondrian and Munch.
Gorky: *Liver is a Cockscomb.* —*How my Mother's Embroidered Apron Unfolds in my Life.*
Hare: *Magician's Game.*
Masson: *Iroquois Landscape.*
Matta: *The Vertigo of Eros.*— *The Window-maker.*
Rothko: *Slow Swirl by the Edge of the Sea.*
Still: *Never.*
Breton: *Arcane 17.*
Mesens: *Third Front.*
Birth of Flexner and Yoshiko.

1945
Death of Desnos, Unik and Valéry.
Exhibition of *Surrealist Diversity* in London.
Hérold: *The Femmoiselle.*
Isabelle Waldberg: *The Sextant.*
Breton: *Surrealism and Painting* (2nd edition).
Gracq: *A Handsome Darkness* (Un Beau Ténébreux).
Monnerot: *Modern Poetry and the Sacred.*
Nadeau: *History of Surrealism.*
Péret: *The Dishonour of Poets.*
Prévert: *Words.*
Birth of Eric Pretz.

1946
Death of Dove, Hirshfield and Paul Nash.
Duchamp began *Given that: 1° The Waterfall, 2° The Gaslighting (Etant donnés: 1° la chute d'eau, 2° le gaz d'éclairage).*
Matta: *The Pilgrim of Doubt.*
Dorothea Tanning: *A Little Nightmusic.*
Toyen: *Myth of the Light.*
Arp: *The Siege of the Air.*
Breton: *Yves Tanguy.*
Césaire: *The Miraculous Arms.*

1947
Death of Léon-Paul Fargue.
International Surrealist exhibition in Paris.
Brauner: *The Louptable.*
Gorky: *Engagement II.*
Gottlieb: *Oracle.*
Magritte: *Philosophy in the Boudoir.*
Newman: *Genetic Moment.*
Roszak: *Spectre of Kitty Hawk.*
Artaud: *Van Gogh or the suicide of society.*
Breton: *Ode to Charles Fourier.*
Chazal: *Plastic Sense II.*
Dominguez: *The Two Who Pass Each Other.*
Leiris-Limbour: *The Universe of André Masson.*
Schehadé: Rodogune Sinne.

1948
Death of Artaud, Crépin, Gorky, Schwitters.
Baziotes: *Mirror Figure.*
Cornell: *Necessary for Soap Bubbles.*
Ernst: *Capricorn.*
Lam: *Beliar, Emperor of the Flies.*
Lipton: *Imprisoned Figure.*
Stamos: *Sacrifice.*
The review, *Néon*, was founded.
Borduas: *Global Refusal.*
Nadeau: *Surrealist Documents.*

1949
Death of Cáceres, Maeterlinck and Torres-Garcia.
Hartung: *T. 1949-9.*
Noguchi: *Koré.*
Birth of Phillip West.

1950
Death of Pierre Roy.
Dali: *Dali at six years of age when he pretended to be a little girl, lifting up the skin of the water to see a sleeping dog in the shadow of the sea.*
Miró: *Portrait.*
Pollock: *Autumn Rhythm.*
Toyen: *All the Elements.*
*Surrealist Almanach of a Half-Century.*
Duprey: *Behind his Double.*
Ionesco: *The Lesson.*

1951
Death of Humphrey Jennings, Karel Teige and Wols.
Hantaï: *Fourth Moulting (Quatrième Mue)*.
Mandiargues: *Sun of the Wolves*.
Prévert: *Spectacles*.
Queneau: *Sunday of Life*.
Schehadé: *Monsieur Bob'le*.

1952
Death of Eluard, Mabille, Savinio and Vitrac.
Gallery, A l'Etoile Scellée, opened in Paris.
Arp: *Cobra-Centaure*.
Bedouin-Péret-Zimbacca: *The Invention of the World*.
Dova: *The Wave*.
*Medium* was founded.
Breton: *Conversations*.

1953
Death of Heisler and Picabia.
D'Orgeix: *The Pierced Ear*.
Paalen: *Portrait of Madame X*.
Svanberg: *The Strange Pregnancy of the Strange Encounter*.
Breton-Heisler-Péret: *Toyen*.
Luca: *Heros-Limited*.
Péret: *Death to the Cows and to Glory (Mort aux Vaches et au Champ d'Honneur)*.

1954
Death of Derain, Lesage, Martini and Matisse.
Dali: *Young virgin sodomised by her own chastity*.
Hantaï: *Composition*.
Moore: *Upright Internal and External Forms*.
Tanguy: *Imaginary Numbers*.

1955
Death of Tanguy.
*Perennial Art of the Gauls* exhibited in Paris.
Klapheck: *Typewriter*.
Oelze: *Oracle*.
Rauschenberg: *The Bed*.
Kay Sage: *Tomorrow is Never*.
Alquié: *Philosophy of Surrealism*.

1956
Death of Marie Laurencin, Moro and Pollock.
Molinier: *Countess Midralgar*.
Mimi Parent: *I live in shock*.
Schröder-Sonnenstern: *The Moralunaire Lesson (Le Cours moralunaire)*.
The review, *Surréalisme, même*, was founded.
Ivsic: *King Gordogane*.
Joyce Mansour: *Julius Caesar*.
Péret: *Anthology of sublime love*.

1957
Death of Bjerke-Petersen, Brancusi and Colinet.
Cardenas: *Couple from the Antilles*.
Rothko: *White and Green on Blue*.
Bataille: *Eroticism*.
Bellmer: *Petits Anatomie de l'Inconscient Physique* or *l'Anatomie de l'Image*.
Benayoun: *Anthology of Non-sense*.
Breton: *Magic Art*.
Hérold: *Maltraité de Peinture*.

1958
Death of Nezval.
Ernst: *Sign for a School of Seagulls*.
Svanberg: *Bouquet of Light and Twilight*.
The review, *Bief*, was founded.
Cabanel, *Black Animal*.

1959
Death of Duprey, Paalen, Péret and Germaine Richier.
International exhibition of Surrealism in Paris: 'Eros'.
Baj: *The Ultrabodies in Switzerland*.
Benoît: *The Execution of the Will of the Marquis de Sade*.
Magritte: *Harvest Months*.
Matta: *The Pool of No*.
Breton: *The 'Constellations' of Miró*.
Lebel: *Concerning Marcel Duchamp*.
Paz: *The Labyrinth of Solitude*.

1960
Death of Blanchard, Borduas, Paul Fort and Reverdy.
International Surrealist exhibition in New York: *'Surrealist Intrusion in the Enchanters' Domain'*.
Masson: *Fertile Night*.
Tinguely: *Homage to New York*.

1961
Death of Madge Gill and Kay Sage.
Calder: *Sumac*.
Fahlström: *Dr. Livingstone, I presume?*
Kienholz: *The Roxy's*.
The review, *La Brèche*, was founded.

Bedouin: *Twenty Years of Surrealism.*

1962
Death of Bataille, Klein, Morris Louis and Seligmann.
Rosenquist: *Skies of Silver.*

1963
Death of Baziotes, Braque, Remedios and Tzara.
Dax: *Au Festin des Nautiles.*
Télémaque: *Family Portrait.*
Bounoure: *Towards the Shadow.*
Levi-Strauss: *Primitive Thought.*

1964
Death of Aloïse, Chaissac, Fautrier and Nadelman.
Gironella: *Big Queen.*
Lam: *Children without Soul.*
Silbermann: *At the wish of the Demoiselles.*
Wiley: *Tomb of the Zebra.*

1965
Death of Kiesler and David Smith.
International Exhibition of Surrealism in Paris: 'L'Ecart Absolu'.
Alechinsky: *Central Park.*
Benoît: *The Necrophile (Homage to Sergeant Bertrand).*
Geis: *Don't Want.*
Klapheck: *Feminine Logic.*
Marjorie Strider: *View from the Window.*
Télémaque: *Travelling Necessities.*
Isabelle Waldberg: *The Great Times (Le Grand Temps).*
Breton: *Surrealism and Painting* (3rd edition).

1966
Death of Arp, Brauner, Breton. Charles Estienne, Giacometti and Marcel Lecomte.
Duchamp finished *Etant donnés: 1° la chute d'eau, 2° le gaz d'éclairage.*
Lagarde: *Saturday, silent and noiseless.*
Marisol: *The Party.*
Oldenburg: *Soft Toilet.*
Niki de Saint-Phalle: *Hon.*
Ursula: *Pandora's Box.*
Arp: *Jours effeuillés.*
Nougé: *The Experience Continues.*

1967
Death of Brunius, Magritte, Nougé, Reinhardt and Sadoul.
Exhibition in Exeter: 'The Enchanted Domain'.
Exhibition in Paris, 'Poetic Fury'.
Camacho: *Ace Des Tr . . .*
Gerber: *I don't want to give up anything of all that.*
Miró: *The Wind Clock.*
Toyen: *Mirage.*
The review, *Archibras*, was founded.
Silbermann: *The Ravisher.*

1968
Death of Duchamp, Valentine Hugo, Paulhan, Herbert Read and Lawrence Vail.
Surrealist exhibition in Prague: 'The Principle of Pleasure'.
The review, *Transforma(c)tion*, was founded.

1969
Death of Chavée, Malkine, Pierre de Massot.
Agar: *The Muscles of Imagination.*
Barker: *Homage to Magritte.*
Dorothea Tanning: *Sin.*
Tsoclis: *Black.*
Wesselmann: *Painting of Room No. 14.*
The review, *Coupure*, was founded.
Schuster: *Archives 57–68, Battles for Surrealism.*

1970
Death of Newman and Rothko.
Exhibition in Stockholm: 'Surrealism'.
Davie: *Bird Spirit.*
Kitchen: *Towers.*
Nemes: *Story of a Mother.*
Rosenquist: *Flamingo Capsule.*
Tovar: *The Demon of the Virgin Forest.*
Westermann: *Little Egypt.*
The review, *Humidity*, was founded.
Audoin: *Breton.*
Ben: *Ecrit pour la gloire á force de tourner en ronde et d'être jaloux.*
Ernst: *Writings.*

1971
Death of Magloire-Saint-Aude, Mesens and John Tunnard
Exhibition in Cologne; 'Der Geist des Surrealismus'.
Von Holten: *Purée Complète.*
Laloy: *Woman and Bird.*
Pereira: *On Opening into Darkness (En s'ouvrant au noir).*
Courtot: *Crossroads of Wanderings.*

Legrand: *Preface to a System of Eternity.*

1972
Death of John Banting, Joseph Cornell and Scottie Wilson.
Cárdenas: *The Little Ball.*
Erró: *Homage to the painter, Arslan.*
Flexner: *Camel, the Hump.*
Giovanna: *Crossed Enamels (Emaux croisés).*
Maddox: *The Fortune Hunters.*
Nutt: *Sally Slips Bye-Bye.*
Thirion: *Revolutionaries without Revolution.*

1973
Death of Hénein, Lipchitz and Picasso.
Pasotti: *Nothing is left of them but a print of grass.*

1974
Benoît: *Box for Magnetic Fields.*
D'Orgeix: *Android of the Queen Mother.*
Tovar: *A Dark Secret.*
Vermeille: *Signs V.*
Alexandrian: *Surrealism and the Dream.*
Leonora Carrington: *The Acoustic Cornet.*
Duits: *Demonic Conscience.*
Legrand: *The Return of Spring.*

1975
Death of Jehan Mayoux.
Marguerite Bonnet: *André Breton, Birth of the Surrealist Adventure.*
José Pierre: *What is Therese? It is the chestnut trees in flower.*
Alain Roussel: *Impossible Text.*

1976
Death of Edward Burra, Calder, Ernst, Fahlström, Malrieu, Molinier, Queneau, Man Ray and Tobey.
Ascal: *May-November 1976.*
Ghez: *The Palagonian Garden.*
Marianne van Hirtum: *The Mathematical Night.*
Lebel: *Saint Charlemagne.*

1977
Death of Jacques Prévert.
Gironella: *The Dream is a Ham.*
Yoshiko: *Fairy Distance (Distance de Fée).*
Blanchard: *Beginning after Death.*
Le Brun: *Drop everything.*

1978
Exhibitions in London: 'Dada and Surrealism reviewed', 'Surrealism Unlimited' and 'The Transforma(c)tion Review'.
Carrington: *The Debutante.*

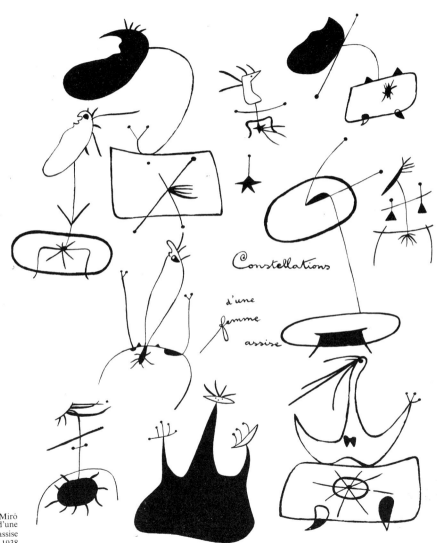

*Constellations*

*d'une*

*femme*

*assise*

Miró
Constellation d'une
femme assise
Indian ink. 1938

# List of Plates

FRANCIS PICABIA
Paris, 1879 – Paris, 1953.
21 Prenez garde à la peinture. 1917.
Fresh Paint *or* Beware of Wet Paint.
22 Parade amoureuse. 1917.
Amorous Parade.
23 Optophone I. 1922.
24 Petite Solitude au milieu des soleils.
Tableau peint pour raconter non pour
prouver. 1919.
A Little Solitude amidst the Suns.
A Picture painted to tell and not to prove.
25 Midi. Vers 1921.
Midday.
New Haven, Yale University Art Gallery.
26 Udnie ou la Danse. 1913.
Udnie or the Dance.
Paris, musée national d'Art moderne.

HANS ARP
Strasbourg, 1887 – Bâle, 1966.
27 Bois peint. 1917.
Painted Wood.
28 Configuration. 1928.
Bâle, Kunstmuseum.
29 Danseuse. 1925.
Dancer.
30 Homme aux trois nombrils. 1920.
Man with Three Navels.
31 Pépin Géant. 1937.
Giant Pip.
Paris, musée national d'Art moderne.

MAX ERNST
Brühl, Germany, 1891 – Seillans, 1976.
32 C'est le chapeau qui fait l'homme.
Papier collé. 1920.
The Hat makes the Man.
New York, Museum of Modern Art.

33 Catherine ondulée. 1920.
Catherine Streaming.
34 Les hommes n'en sauront rien. 1923.
Of this Men will know Nothing.
London, Tate Gallery.
35 Jeunes Filles et singe. 1927.
Girls with a Monkey.
36 Le Chaste Joseph. 1928.
Chaste Joseph.
37 La Forêt grise. 1926.
The Grey Forest.
38 Napoléon dans le desert. 1941.
Napoleon in the Desert.
New York, Museum of Modern Art.
39 L'Oiseau rose. 1956.
The Pink Bird.
Berlin, National Gallery.
40 Mère et enfants sur le globe terrestre.
Mother and Children on the Terrestrial
Globe.
Mannheim, Kunsthalle.

MAN RAY
Philadelphia, 1890 – Paris, 1976.
41 Object de destruction.
Drawing reproducing the object of 1932.
Object of Destruction.
42 A l'heure de l'Observatoire – les amoureux.
1932-1934.
At the Hour of the Observatory – the
Lovers.

ANDRÉ MASSON
Balagny, 1896.
43 Amphore. 1925.
44 Gradiva. 1939.
45 Niobé. 1947.

## ALBERTO GIRONELLA
Mexico, 1929.
119   Crevette qui dort. 1977.
     Sleeping Shrimp.
     Mexico, fundacion cultural Televisa.
120   Le Songe de la très blanche. 1977.
     The Dream of the White One.
     Mexico, fundacion cultural Televisa.
121   Le Frisson. 1977.
     The Shudder.
     Mexico, fundacion cultural Televisa.
122   Grande Reine. 1964.
     Great Queen.

## THEO GERBER
Thoune, Suisse, 1928.
123   Printemps imaginaire. 1970.
     Imaginary Spring.
124   Il mio mundo. 1970.
125   L'Oeuf de Christophe Colomb. 1965.
     The Egg of Christopher Columbus.
126   Venus cessa de nous cacher les zones
     désertiques. 1967.
     Venus no longer hid the Desert Zones
     from us.

## IVAN TOVAR
San Francisco de Macoris, Saint-Domingue,
1942.
127   Le Démon de la forêt vierge. 1970.
     The Demon of the Virgin Forest.
128   Un lourd secret. 1974.
     A Deep Secret.

## YOSHIKO
Tokyo, 1944.
129   Distance de Fée. 1977.
     Distance of a Fairy.

The abbreviated form of this volume imposes a lamentably arbitrary limit on the number of artists who can be mentioned and the following were equally worthy of inclusion: Victor Brauner, Jindrich Styrsky, Wilhelm Freddie, Henry Moore, Stanley William Hayter, Richard Oelze, Kurt Seligmann, Gordon Onslow-Ford, Frida Kahlo de Rivera, E.F. Granell, Enrico Donati, Maria, Riopelle, Adrien Dax, Pierre Molinier, Yves Laloy, Meret Oppeheim, Leonora Carrington, Remedios and many others. The same limits apply to the biographical indications which have been reduced to places and date of birth and of death. Anybody wishing more information should read 'The Pocket Dictionary of Surrealism' by the same author and the same publisher. Every artist mentioned in this book benefits from a more detailed notice with the exception of a newcomer, Yoshiko. She is Japanese and after a successful career as an announcer on Japanese television she came to France to devote herself exclusively to painting and her first exhibition was held in Paris in 1977.

# ANDRÉ BRETON

O substance, m'écriai-je, il faut donc toujours en revenir aux ailes de papillon !

<div align="right">A.B. 1936</div>

O substance, I cried, we must yet return to the wings of a butterfly !

<div align="right">A.B. 1936</div>

1
Papillon.
Compliment
1961
Butterfly.
Compliment

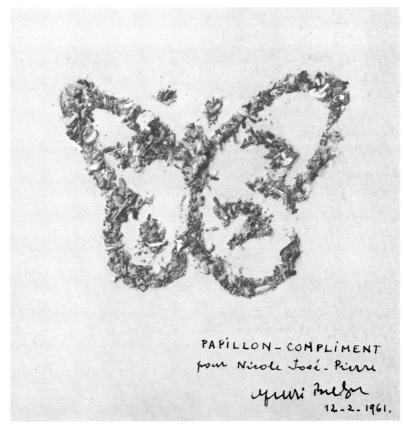

PAPILLON – COMPLIMENT
pour Nicole José-Pierre
André Breton
12-2-1961.

3
Le Poète et sa muse
1909
The Poet
and his Muse

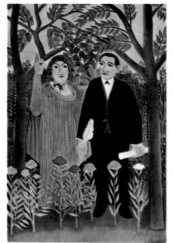

# HENRI ROUSSEAU

2
La Bohémienne
endormie
1897
Sleeping Gipsy

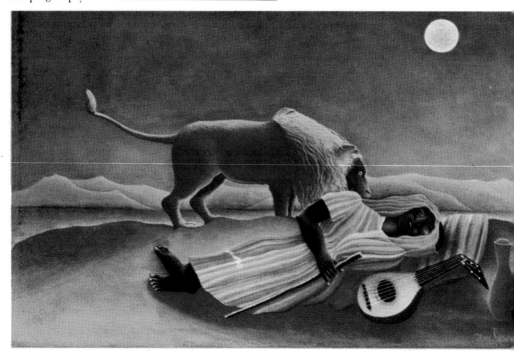

5
La Charmeuse de serpents
1907
The Snake-charmer

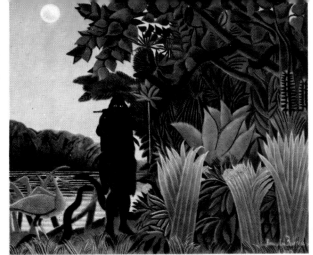

4
Forêt vierge au soleil
couchant.
Nègre attaqué
par un léopard.
1907
Virgin Forest at Sunset.
Negro attacked
by a Leopard.

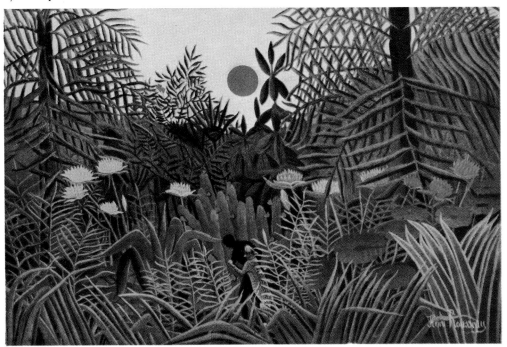

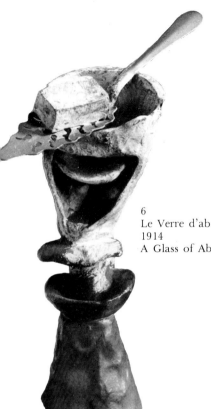

6
Le Verre d'absinthe
1914
A Glass of Absinth

7
Nature morte
1911-1912
Still-life

# PABLO PICASSO

8
L'Homme à la guitare
1913
Man with a Guitar

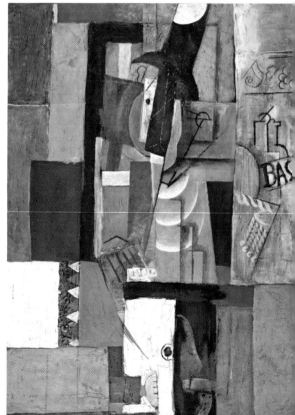

9
Le Sauvetage
1932
The Rescue

GIORGIO DE CHIRICO

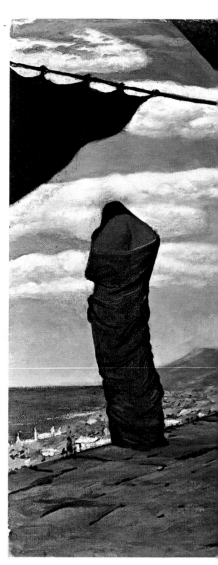

10
L'Enigme de l'oracle
1910
The Enigma of the Oracle

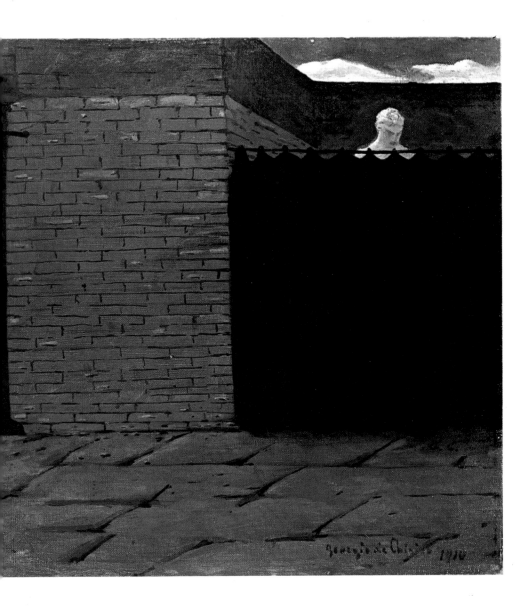

12
L'Enigme de l'Heure
1912
The Enigma of the Hour

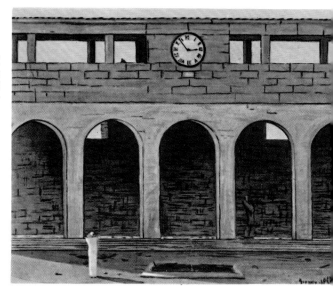

11
L'Enigme de l'arrivée
1912
The Enigma of the Arrival

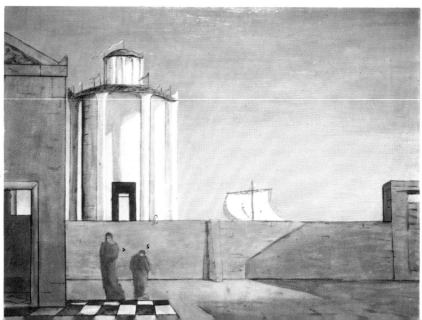

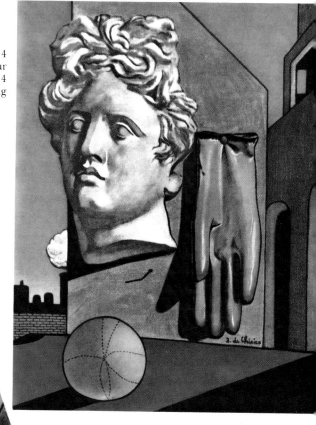

14
Le Chant d'amour
1914
The Love Song

13
L'Enigme de la fatalité
1914
The Enigma of Fatality

15
Le Grand Métaphysicien
1917
The Great Metaphysician

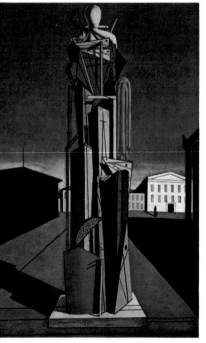

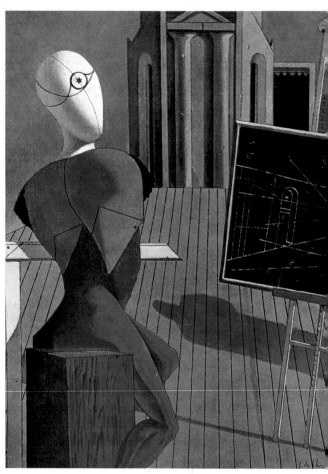

16
Le Vaticinateur
1915

# MARCEL DUCHAMP

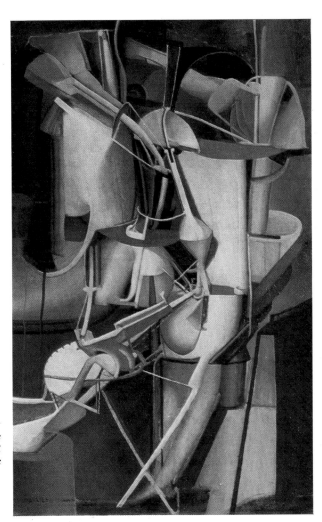

17
La Mariée
1912
The Bride

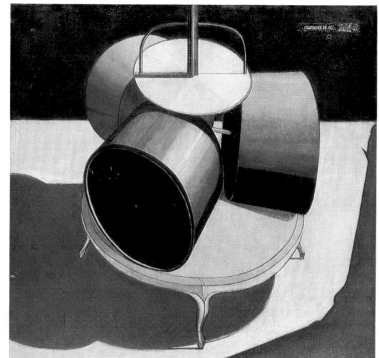

19
Broyeuse de chocolat
1913
Chocolate Grinder

18
Why not sneeze,
Rose Sélavy
Ready made
1921

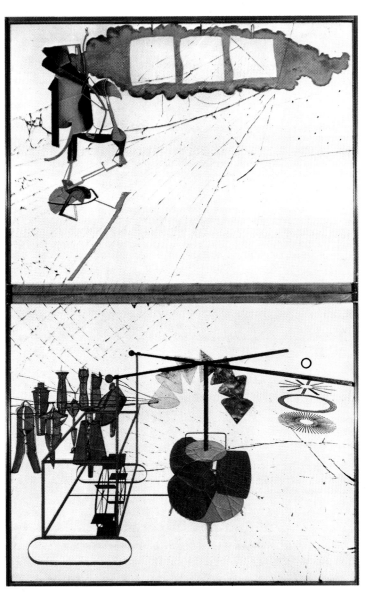

20
La Mariée mise à nu
par ses célibataires même
1915-1923
The Bride stripped bare
by her Bachelors, even

# FRANCIS PICABIA

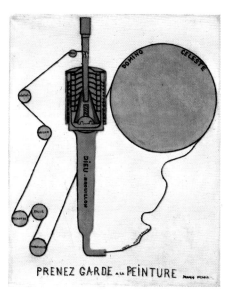

21
Prenez garde à la peinture
1917
Fresh Paint

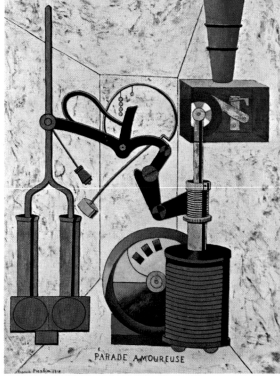

22
Parade amoureuse
1917
Amorous Parade

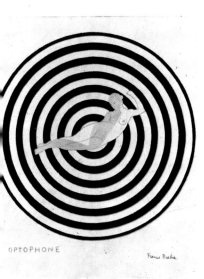

23
Optophone
1921

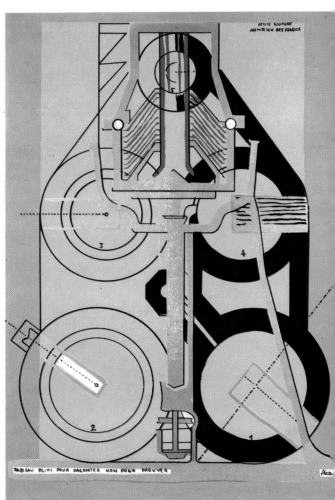

24
Petite Solitude
au milieu des soleils
Tableau peint pour raconter
non pour prouver
1919
A Little
Solitude amidst the Suns
A Picture painted to tell
and not to prove

26
Udnie ou la Danse
1913
Udnie or the Dance

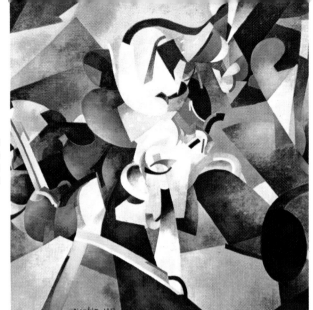

25
Midi
ca 1921
Midday

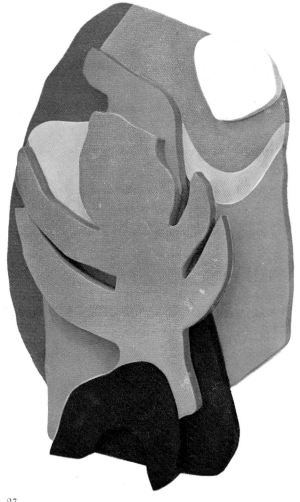

# HANS ARP

27
Bois peint
1917
Painted Wood

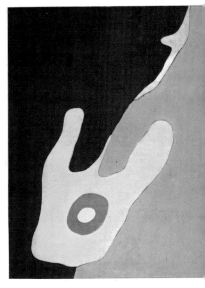

28
Configuration
1928

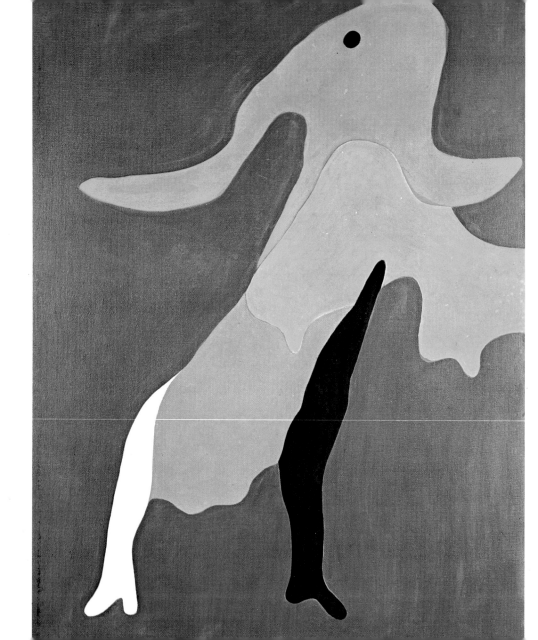

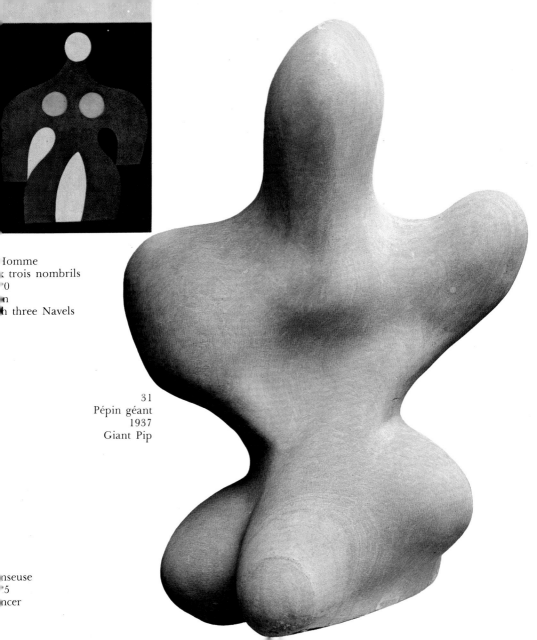

Homme
à trois nombrils
'0
n
h three Navels

31
Pépin géant
1937
Giant Pip

nseuse
'5
ncer

# MAX ERNST

Catherine ondu
19
Catherine Streami

32
C'est le chapeau qui fait l'homme
1920
The Hat makes the Man

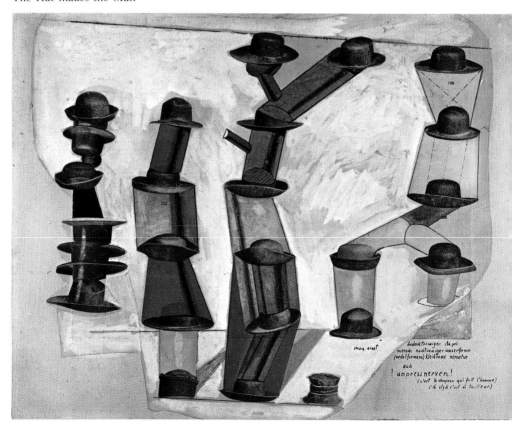

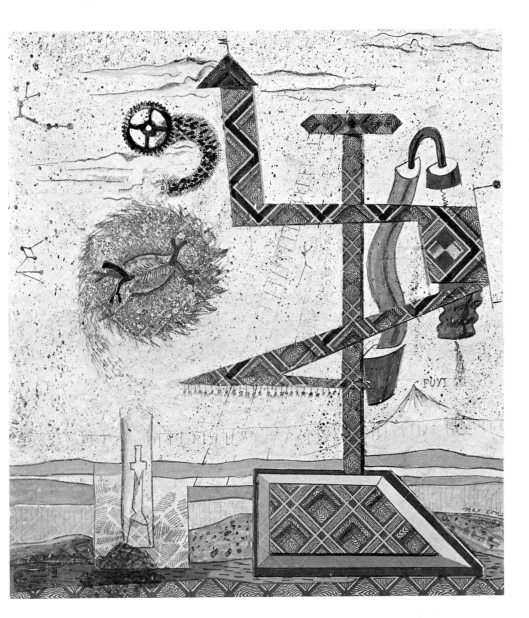

34
Les Hommes n'en sauront rien
1923
Of this Men will know nothing

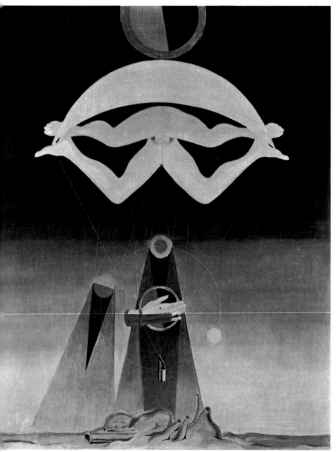

36
Le Chaste Joseph
1928

35
Jeunes filles et singe
1927
Girls with a Monkey

37
La Forêt grise
1926
The Grey Forest

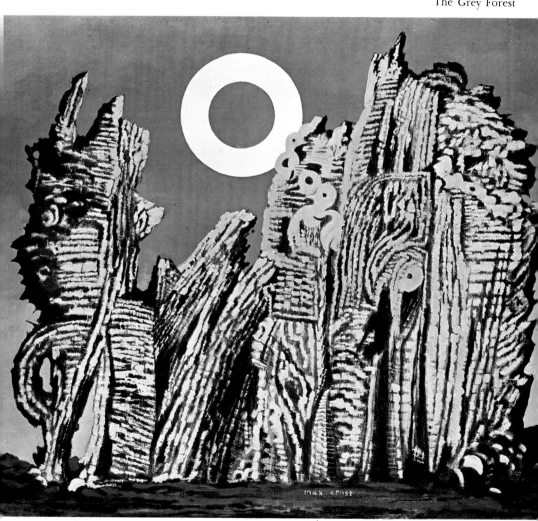

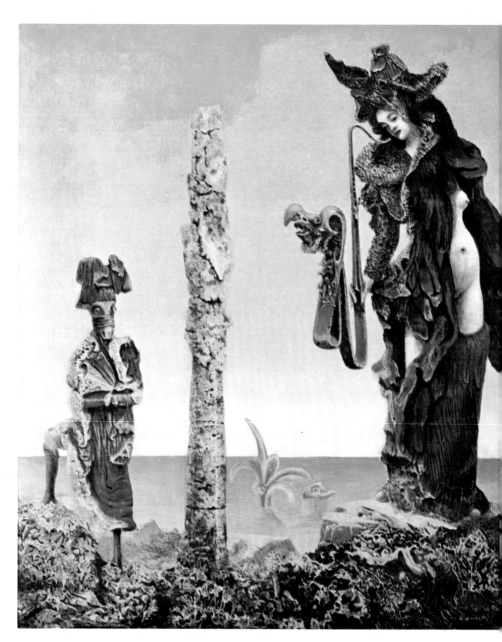

apoléon dans le désert
41
apoléon in the Desert

40
Mère et enfants
sur le globe
terrestre
1952
Mother
and Children
on the terrestrial
Globe

iseau rose
56
ie Pink Bird

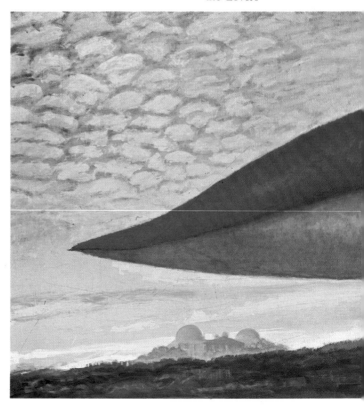

MAN RAY

41
Objet de destruction
1932
Object of Destruction

42
A l'heure de l'Observatoire
les amoureux
1932-1934
At the Hour
of the Observatory
the Lovers

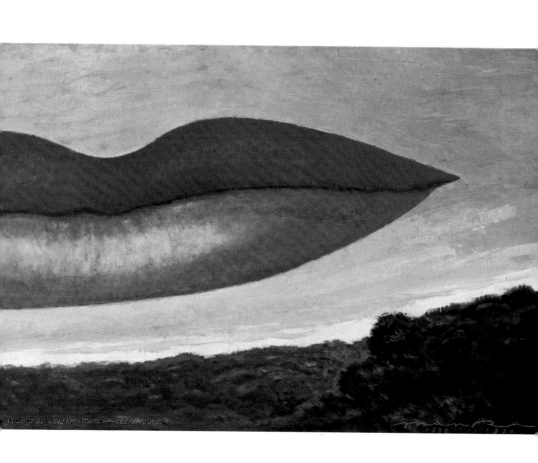

# ANDRĒ MASSON

43
Amphore
1925

44
Gradiva
1939

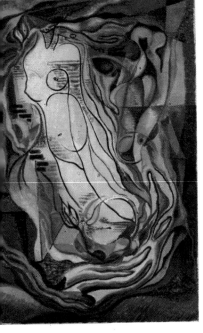

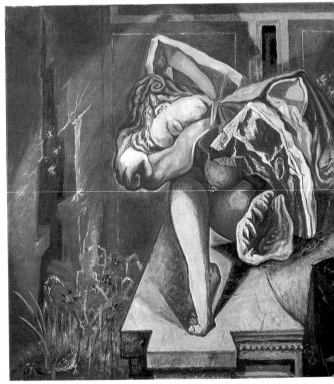

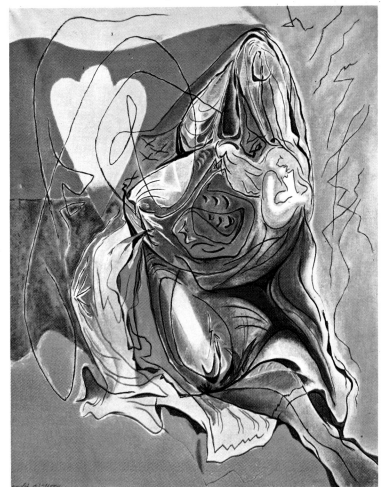

45
Niobé
1947

# JOAN MIRÓ

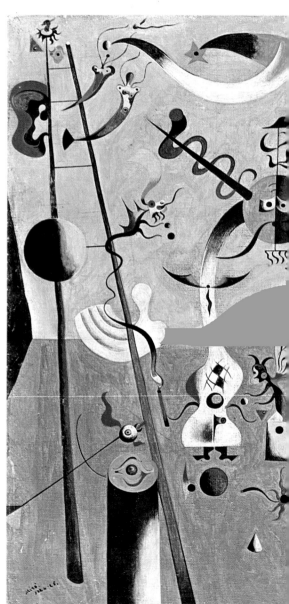

46
Le Carnaval d'Arlequin
1924-1925
The Harlequin's Carnival

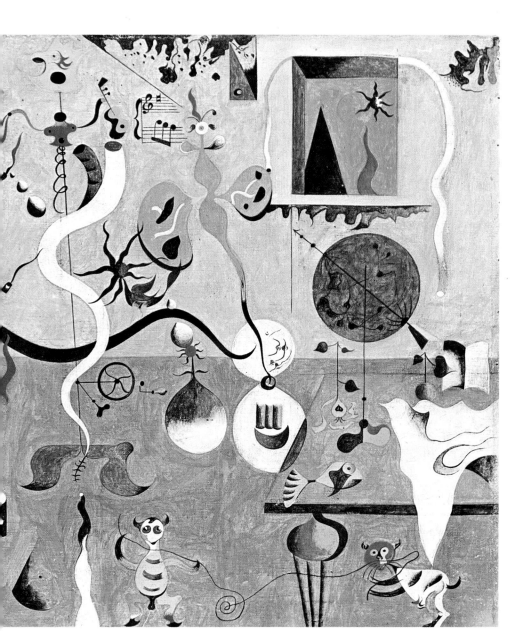

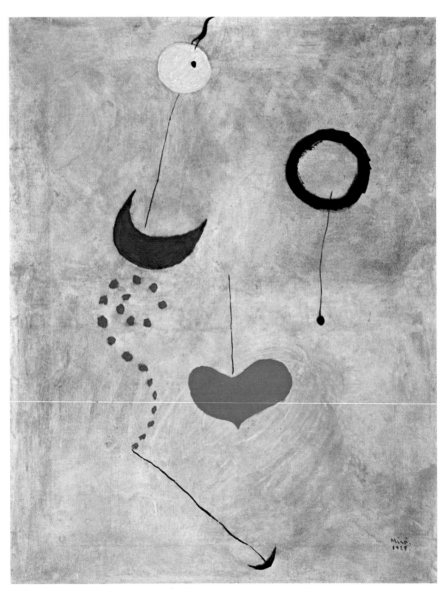

47
Le Cœur
1925
The Heart

50
L'Oiseau nocturne
1939
The Bird of Night

48
Personnage
contemplant
le soleil
1942
Person looking
at the Sun

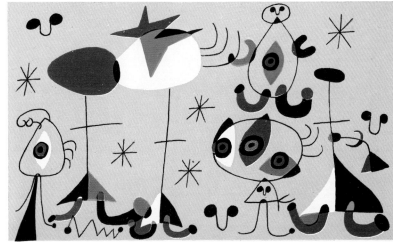

49
Soirée snob
chez la Princesse
1944
Snob Party
at the Princess's

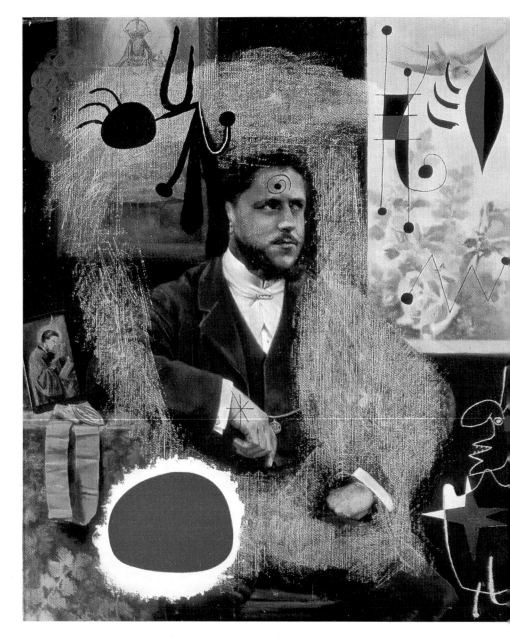

52
Rosée matinale
au clair de lune
1947
Morning Dew
in the Moonlight

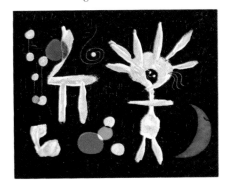

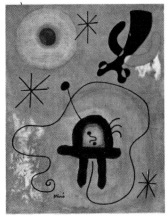

54
Le Mauve de la lune
1951
The Mauve of the Moon

ortrait
50

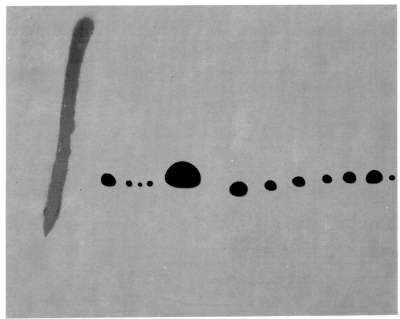

53
Bleu 2
1961
Blue 2

# YVES TANGUY

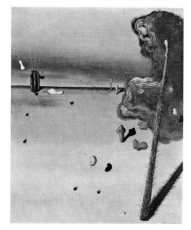

Quatre heures d'ét[...]
l'espo[...]
192[...]
Four O'cloc[...]
in the Summe[...]
Hop[...]

56
Maman,
Papa est blessé !
1927
Mummy,
Papa is wounded !

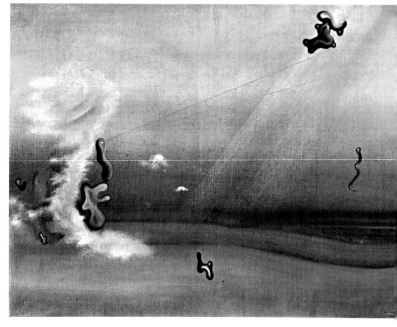

55
Sans titre, Without Title
1929

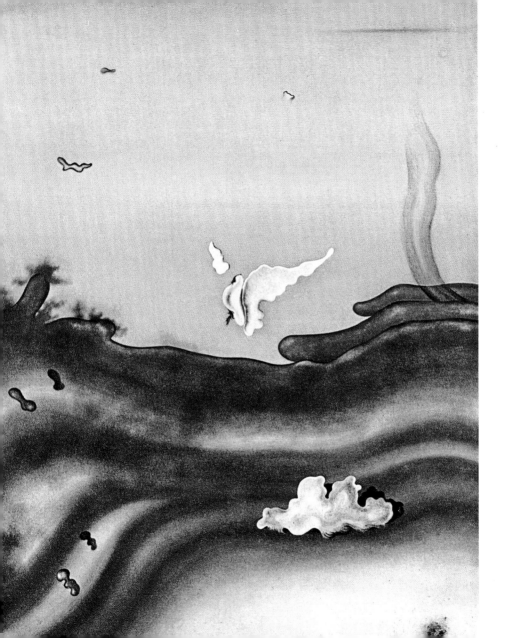

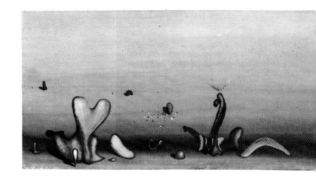

58
Les oreilles d'un sourd
1938
The Ears of a Deaf Man

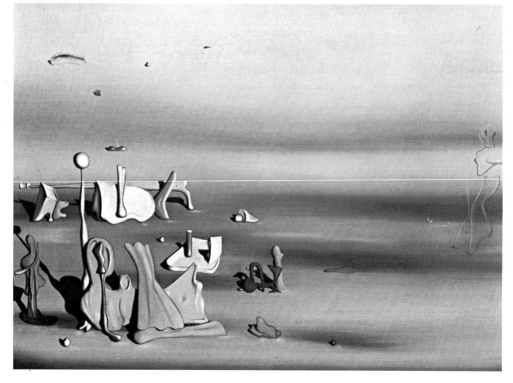

59
Composition

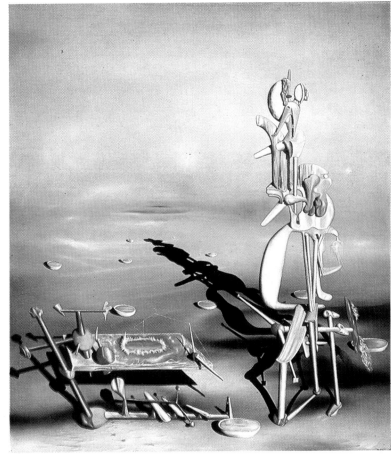

60
Divisibilité infinie
1942
Infinite Divisibility

61
Nombres
imaginaires
1954
Imaginary
Numbers

# RENÉ MAGRITTE

62
Le Temps menaçant
1928
Threatening Weather

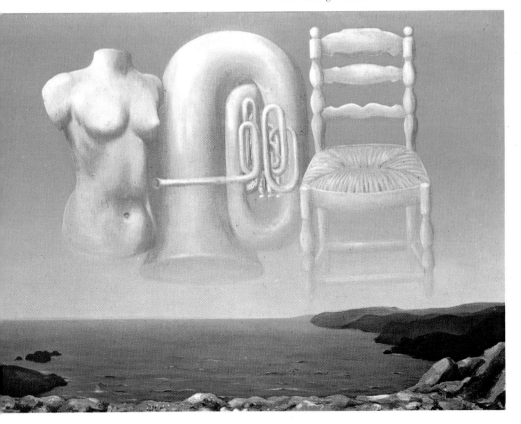

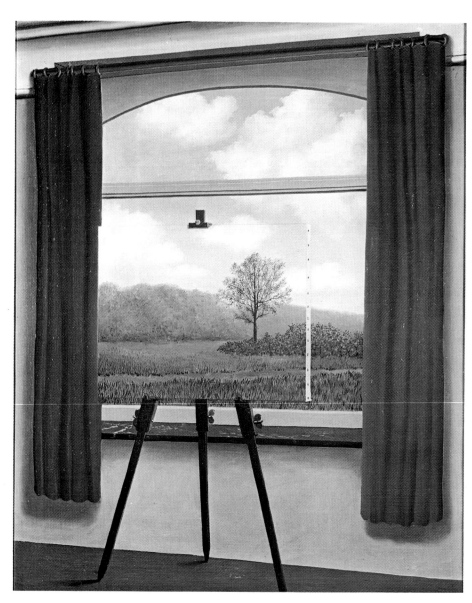

63
La
Conditi‹
humaine
1935
The Hu
Conditi‹

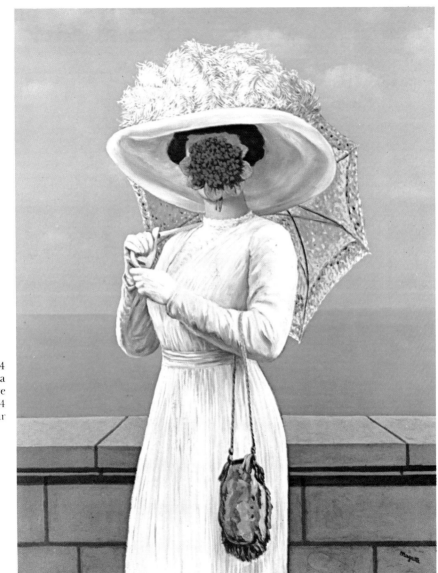

64
La
rande Guerre
1964
he Great War

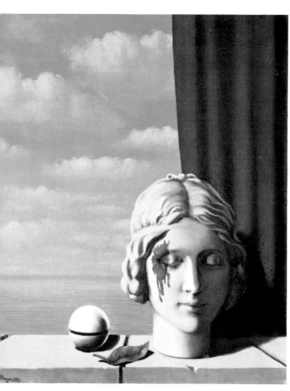

65
La Mémoire
1948
Memory

66
Le Mois des Vendanges
1959
The Grape Harvest

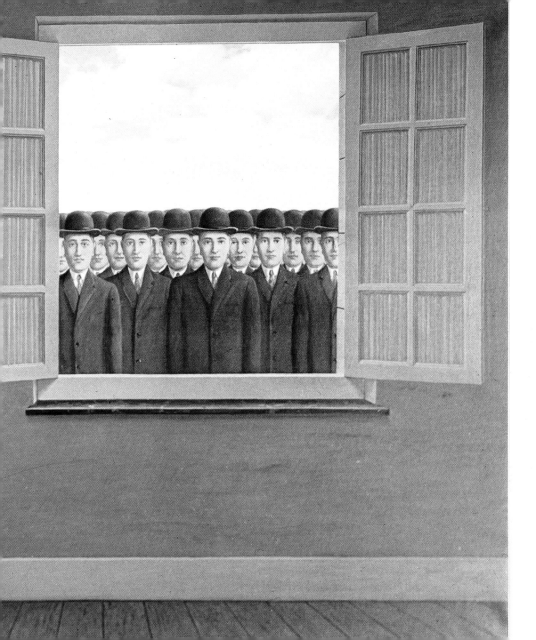

67
Les Plaisirs illuminés
1929
Illuminated Pleasures

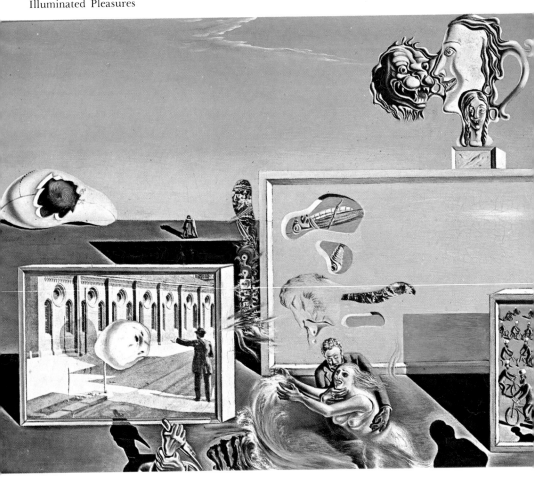

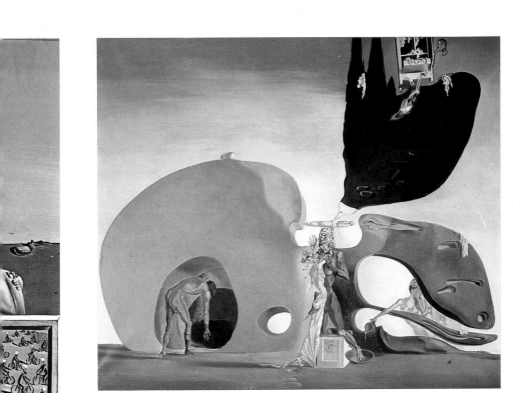

68
Naissance des désirs liquides
1932
The Birth of liquid Desires

70
Six apparitions de Lénine
sur un pianoforte
1931
Six apparitions of Lenin
on a Piano

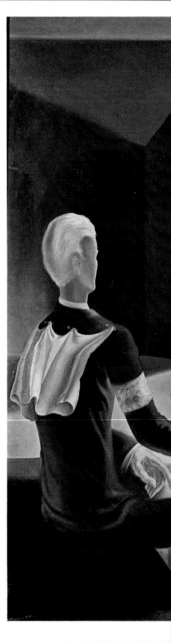

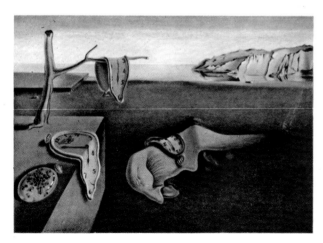

69
Persistance de la mémoire
1931
Persistence of Memory

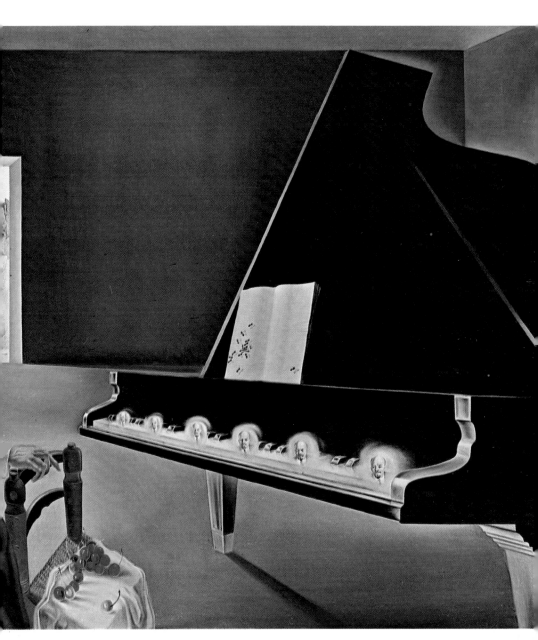

71
Le Spectre de Vermeer
pouvant être utilisé
comme table
1934
The Ghost of Vermeer
which can be used
as a Table

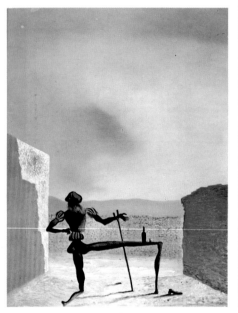

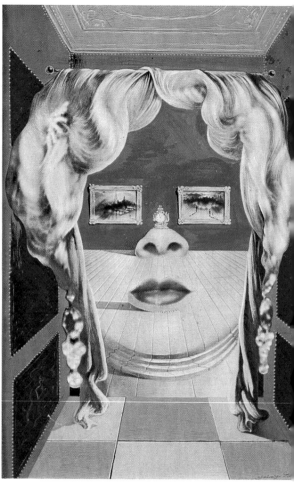

72
Mae West
ca 1934-1936

73
Dali à l'âge de six ans, quand il se prenait pour une petite fille,
soulevant la peau de l'eau pour voir
un chien endormi à l'ombre de la mer
1950
Dali at six years of age, when he pretended to be a little girl,
lifting up the skin of the water to see
a sleeping dog in the shadow of the sea

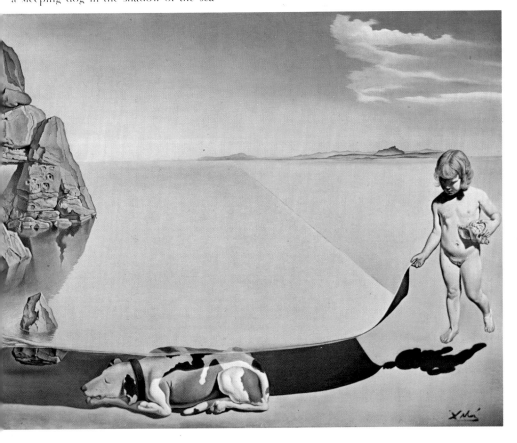

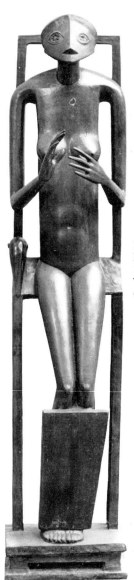

ALBERTO GIACOMETTI

74
L'Objet invisible
1934-1935
The Invisible
Object

La Boule suspend
c
l'Heure des trac
19
The Suspended B
or t
Hour of Trac

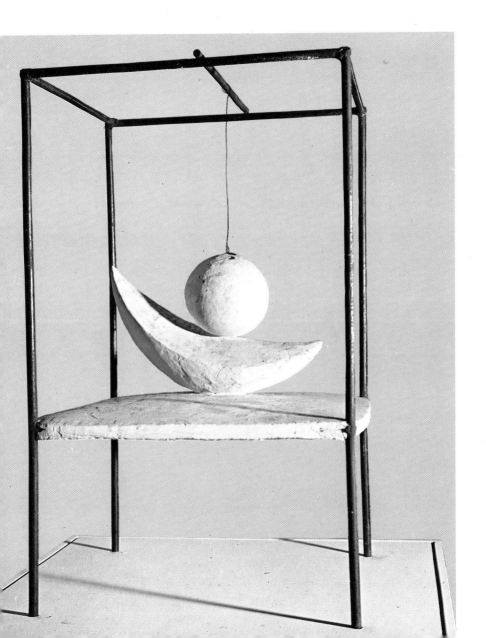

# OSCAR DOMINGUEZ

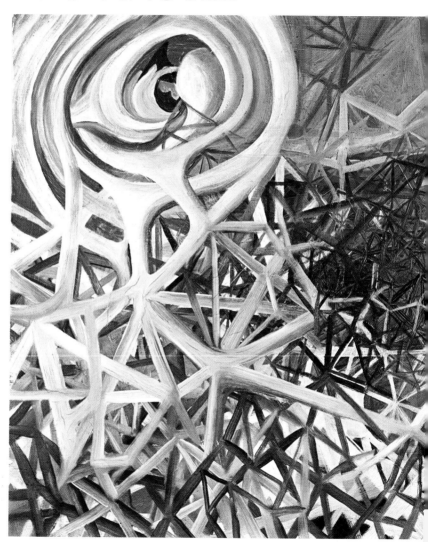

76
Le Bois
1938
The Wood

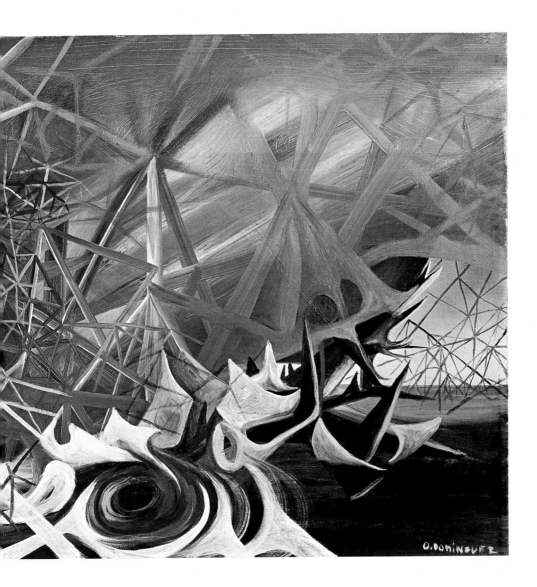

# TOYEN

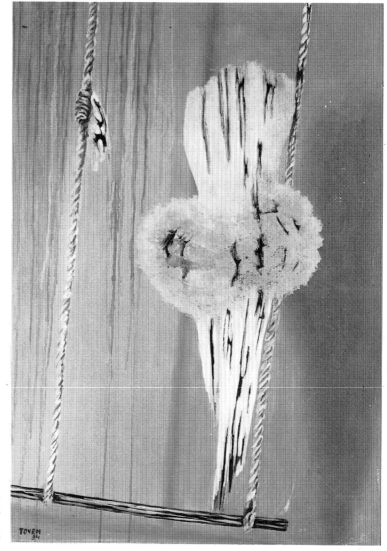

77
Le Spectre rouge
1934
The Red Spectre

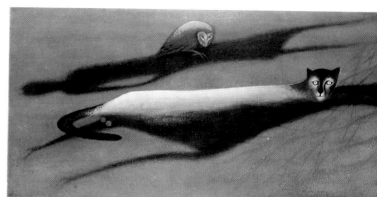

79
Mirage
1967

78
Tous les éléments
1950
All the Elements

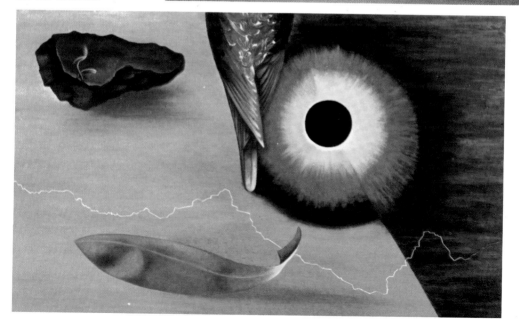

WOLFGANG PAALEN

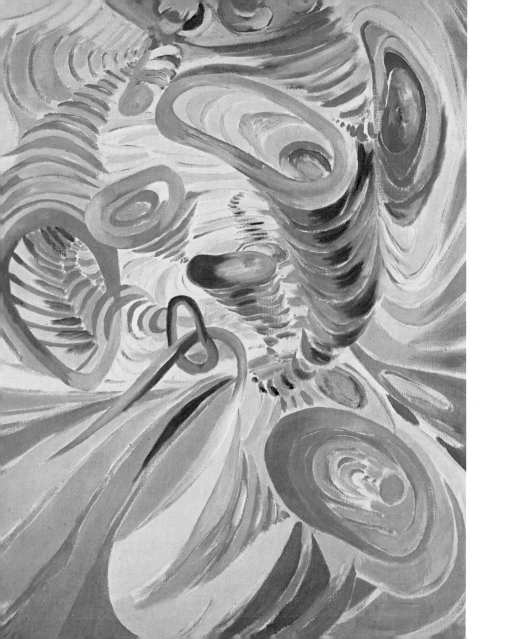

HANS BELLMER

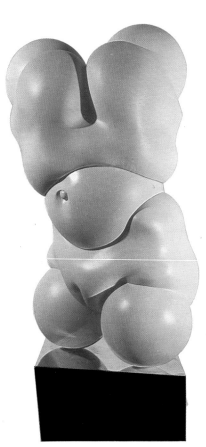

82
Poupée
1936
Doll

83
Dessin
1965
Drawing

8
Jointure de boul
193
Joining Ba

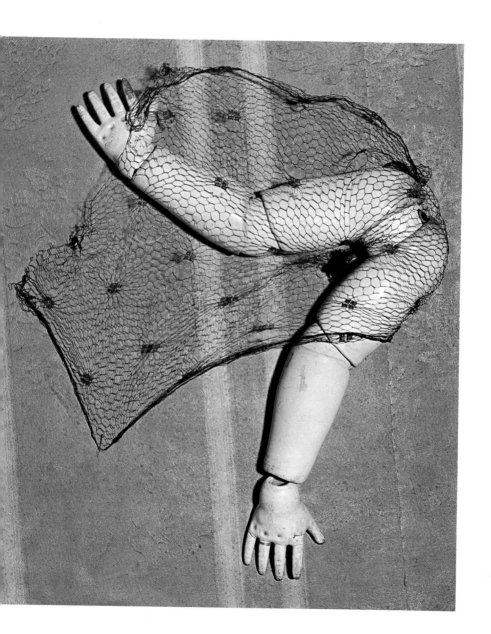

# MATTA

85
Réussite au vitreur
1947
Success to the Glazier

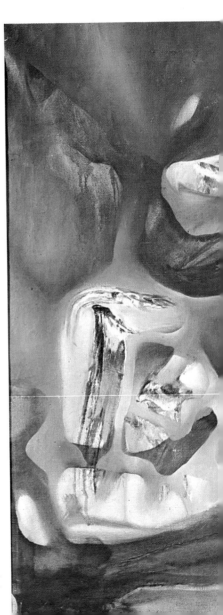

86
Morphologie psychologique
1938
Psychological Morphology

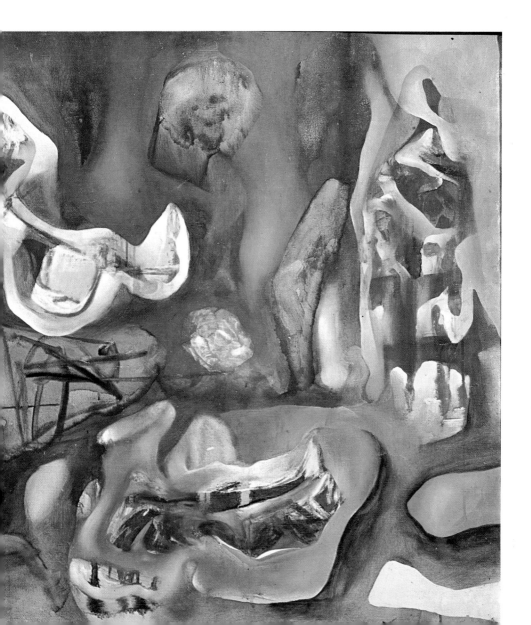

87
Ecoutez vivre
1941
Listen to Living

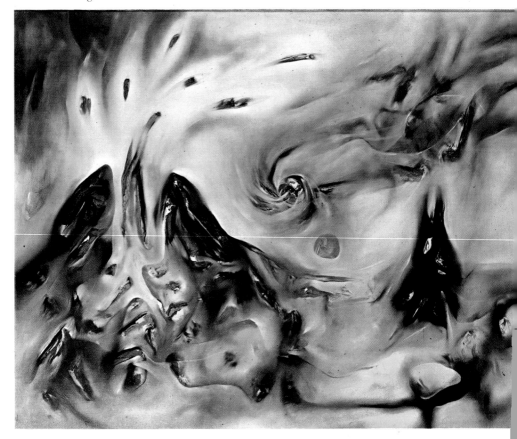

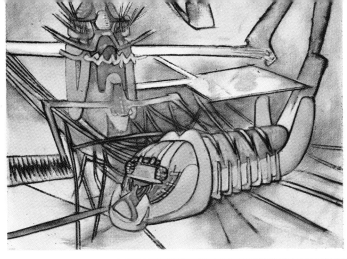

88
Who's who
1955

89
Elle Hegramme
à l'étonnement général
1969
Elle Hegramme
to the Surprise
of Everyone

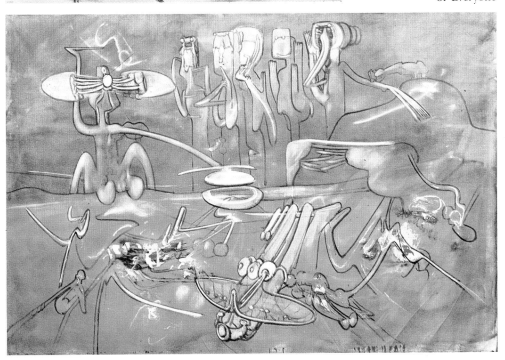

# JACQUES HÉROLD

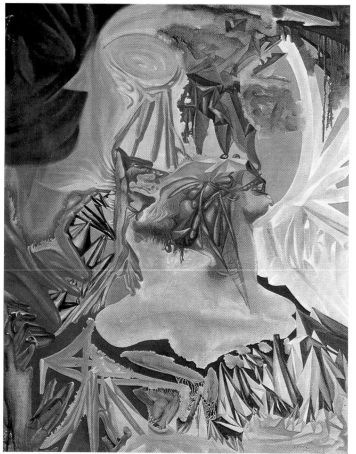

90
Têtes
1939
Heads

Projet de costume
pour
« la Nourrice de la forêt »
19
Costume Project
for
"The Nurse of the Forest"

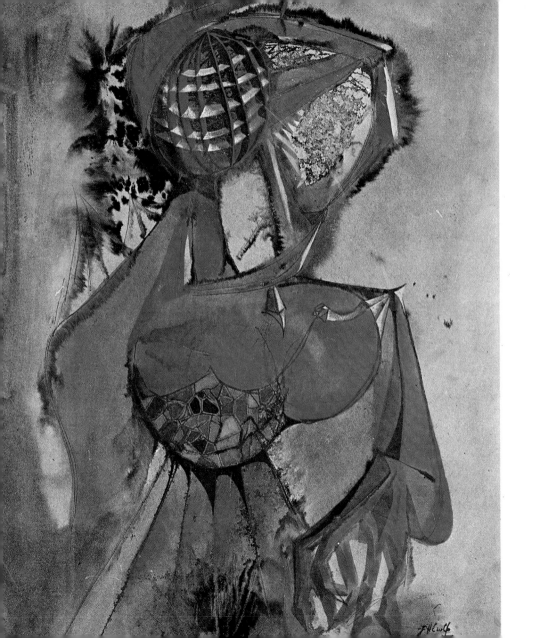

# WILFREDO LAM

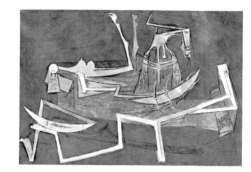

92
Jungle
1944

93
Tropique
du Capricorne
1961
Tropic of Capricorn

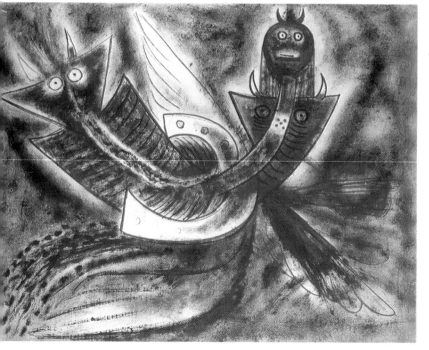

Matern
19
Matern

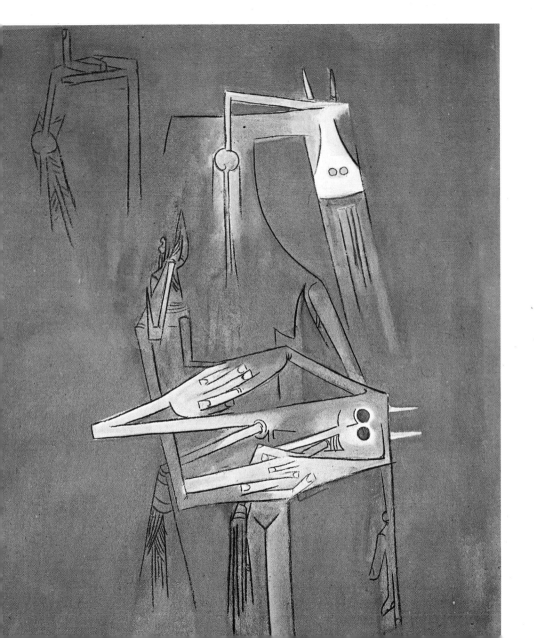

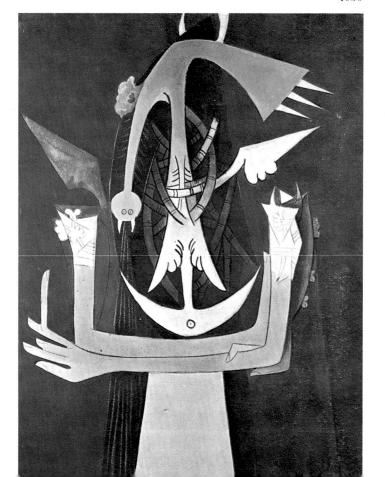

# ARSHILE GORKY

96
Bonsoir, Madame Lincoln
1944
Good Evening, Mrs Lincoln

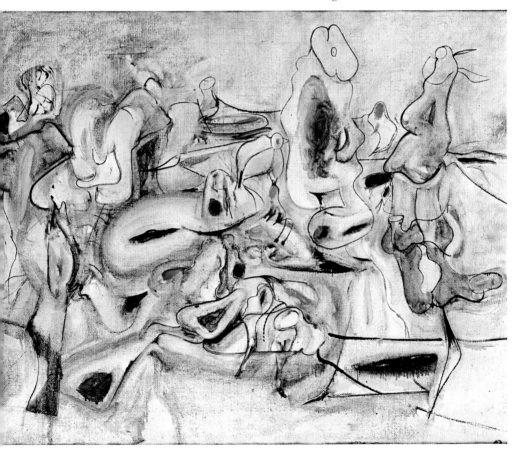

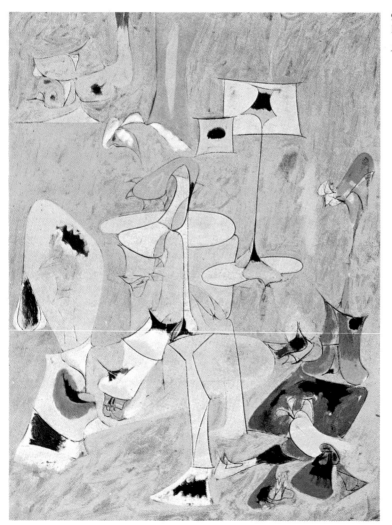

97
Les Fiançailles II
1947
The Betrothal II

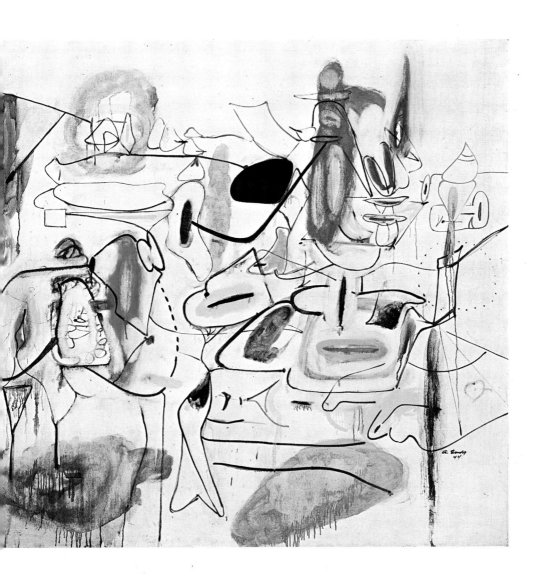

# SIMON HANTAÏ

99
Composition
1952

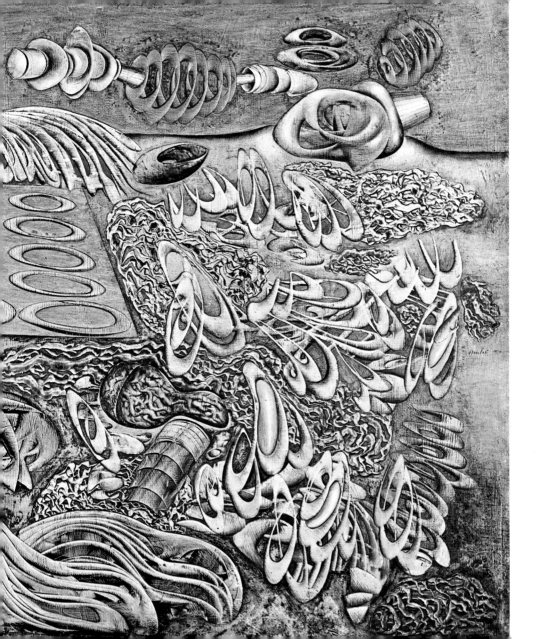

<div style="writing-mode: vertical">MAX WALTER SVANBERG</div>

101
Offrande aux
dames de la lune
1957
Offering to
the Ladies of the Moon

100
Illustration pour
les Illuminations
de Rimbaud
1958

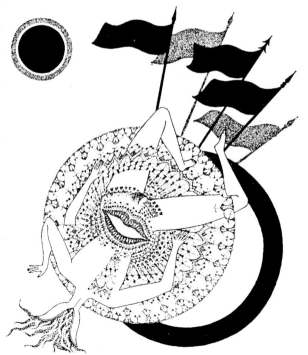

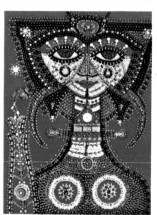

102
Portrait d'une étoile
1952
Portrait of a Star

10
La Grossesse étrang
de la rencontre étrang
195
The Strange Pregnanc
of the strange Meetin

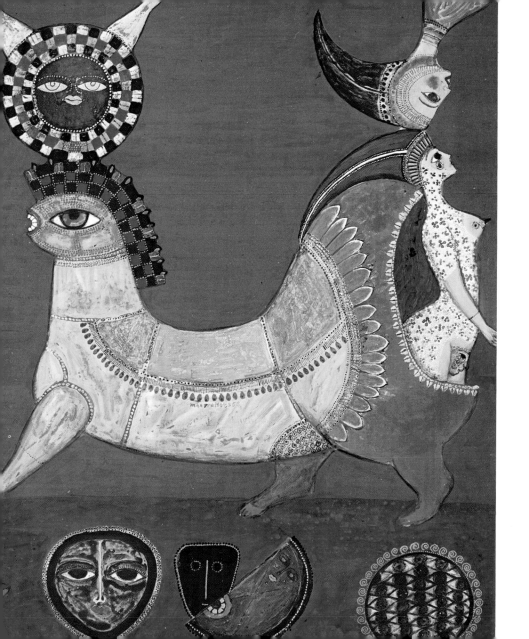

# AGUSTIN CÁRDENAS

4
ns drapeau
72
thout a Flag

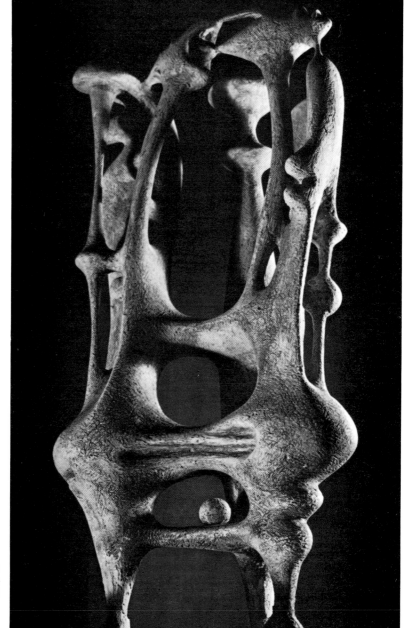

105
Sculpture
1955

# JEAN BENOÎT

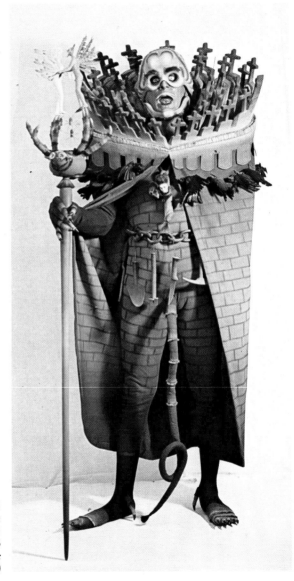

106
Le Nécrophile
(Hommage au sergent Bertrand)
1964-1965
The Necrophile
(dedicated to Sergeant Bertrand)

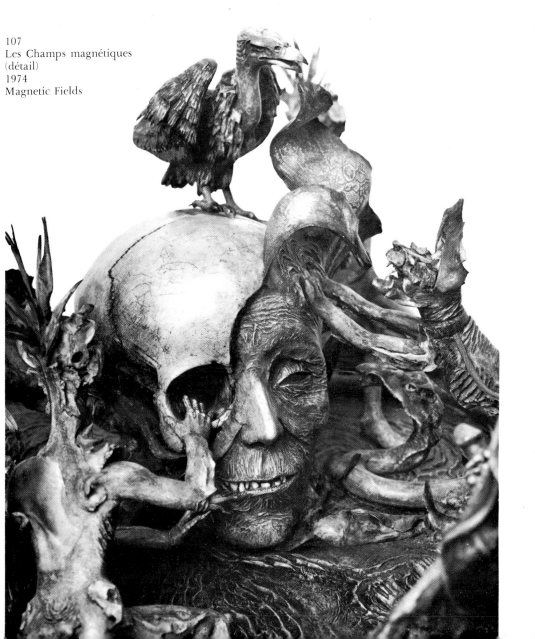

107
Les Champs magnétiques
(détail)
1974
Magnetic Fields

JORGE CAMACHO

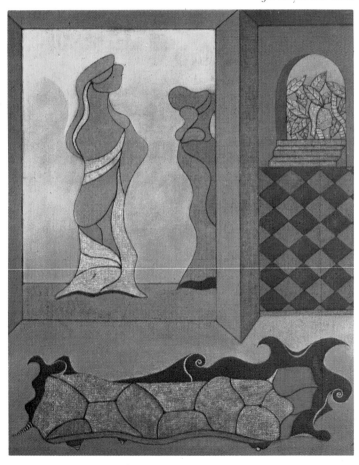

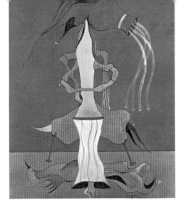

110
Duplicata
1966

109
Ace Des Tr
1967

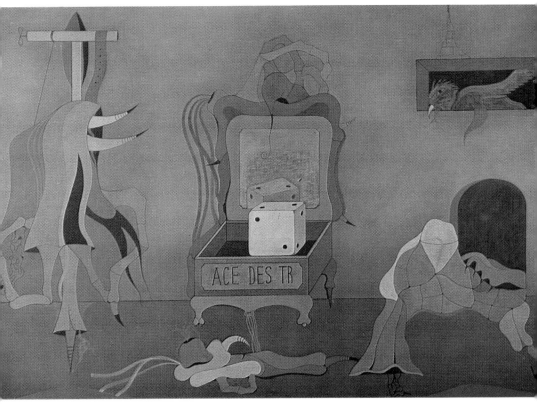

# JEAN-CLAUDE SILBERMANN

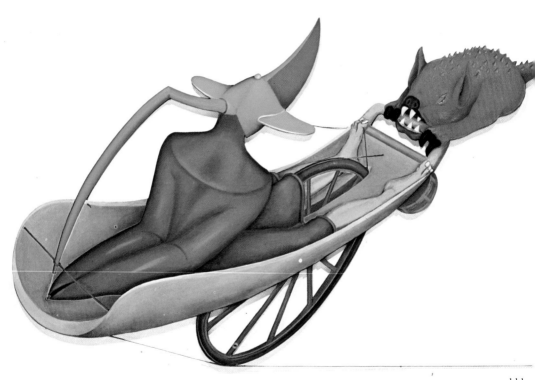

111
Chez mémé
1974
At Grandma's

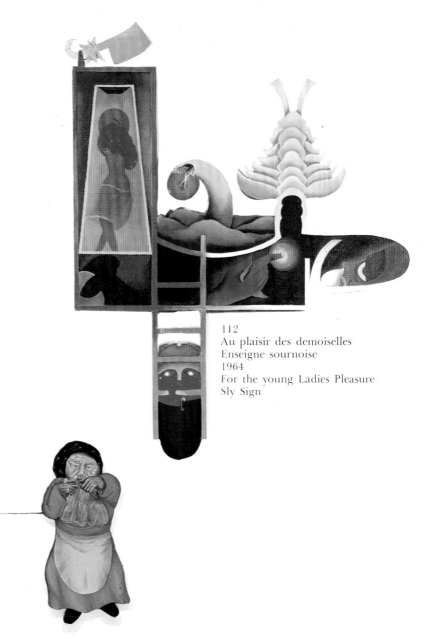

112
Au plaisir des demoiselles
Enseigne sournoise
1964
For the young Ladies Pleasure
Sly Sign

113
La Logique
des femmes
1965
Feminine Logic

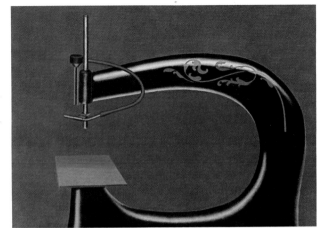

115
La Partenaire dangereuse
1958
The Dangerous Partner

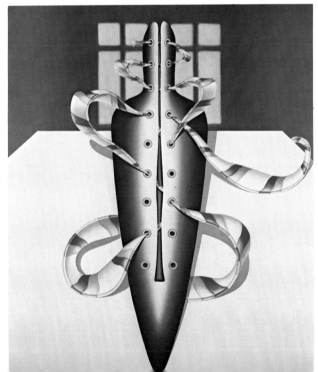

114
Coquetterie
1968

# HERVĒ TĒLĒ/\AQUE

116
Eclaireur II
1962-1965
Scout II

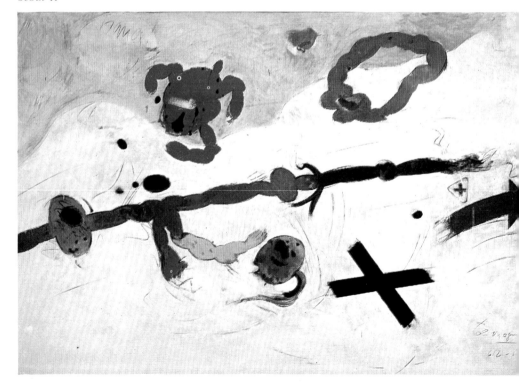

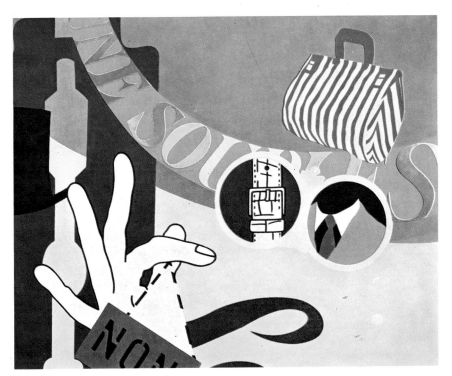

117
Nécessaire de voyage
1965
Travelling Kit

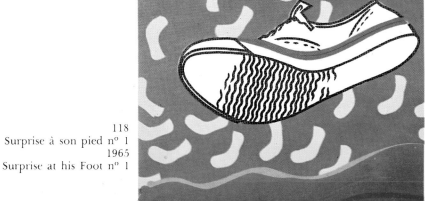

118
Surprise à son pied n° 1
1965
Surprise at his Foot n° 1

# ALBERTO GIRONELLA

120
Le Songe de la très blanche
1977
The Dream of the white one

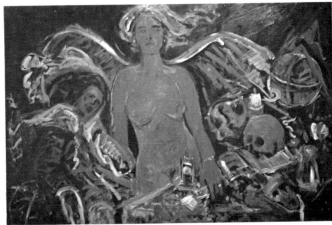

119
Crevette qui dort
1977
Sleeping shrimp

121
Le Frisson
1977
The Shudder

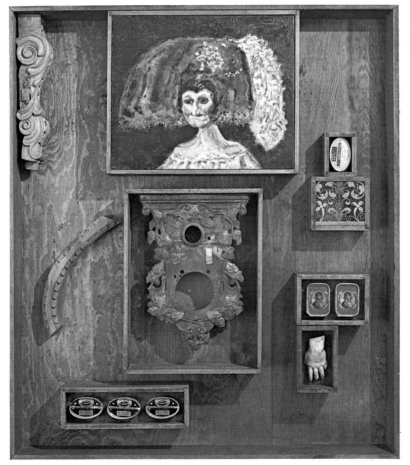

# THEO GERBER

123
Printemps
imaginaire
1970
Imaginary Spring

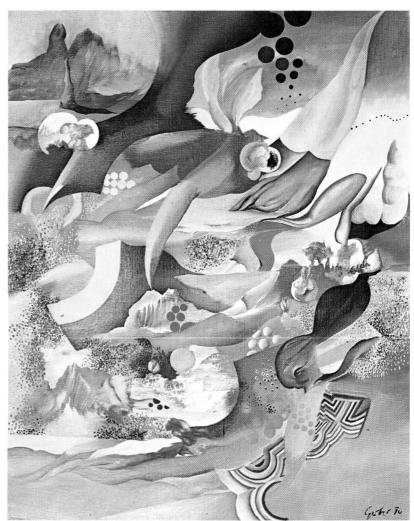

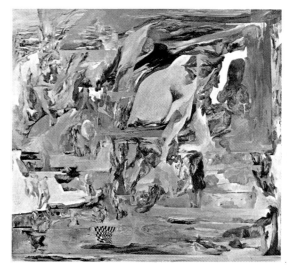

125
L'Œuf de
Christophe Colomb
1965
The Egg of
Christopher Columbus

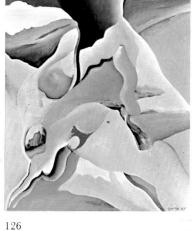

126
Vénus cessa de
nous cacher
les zones désertiques
1967
Venus no longer hid
the Desert Zones
from us

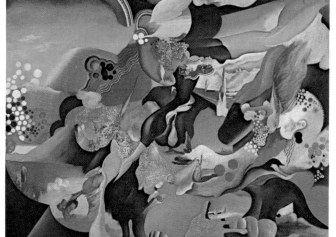

124
Il mio mondo
1970

# IVAN TOVAR

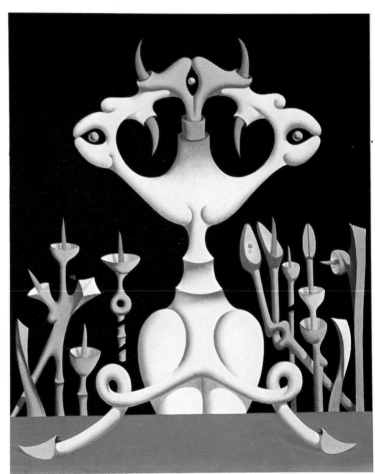

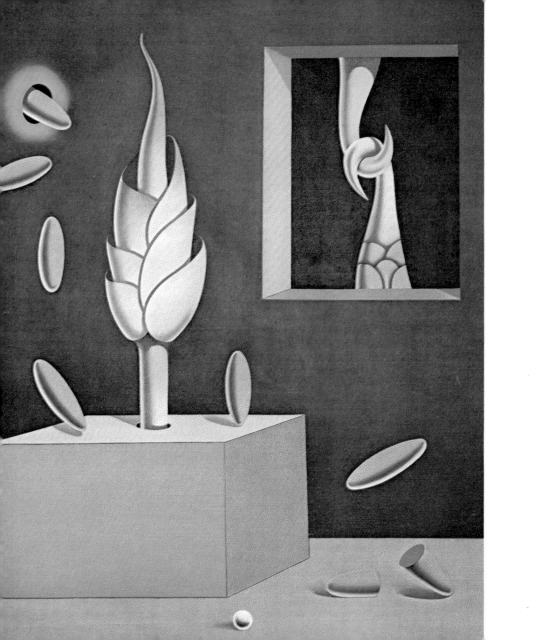

# YOSHIKO

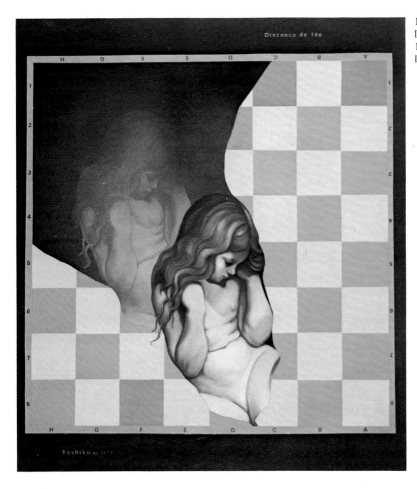

129
Distance de Fée
1977
Distance of a Fairy